THE BURLINGTON COUNTY PRISON

THE BURLINGTON COUNTY PRISON

DENNIS RIZZO & DAVE KIMBALL

Published by The History Press
Charleston, SC 29403
www.historypress.net

Copyright © 2011 by Historic Burlington County Prison Museum Association
All rights reserved

First published 2011

Manufactured in the United States

ISBN 978.1.60949.105.5

Library of Congress Cataloging-in-Publication Data

Rizzo, Dennis C.
The Burlington County Prison : stories from the stones / Dennis C. Rizzo and Dave Kimball.
p. cm.
ISBN 978-1-60949-105-5
1. Burlington County Jail (Burlington, N.J.)--History. 2. Prisoners--New Jersey--Burlington County--History. I. Kimball., Dave. II. Title.
HV8746.U62B87 2011
365'.974961--dc22
2010048605

Notice: The information in this book is true and complete to the best of our knowledge. It is offered without guarantee on the part of the authors or The History Press. The authors and The History Press disclaim all liability in connection with the use of this book.

All rights reserved. No part of this book may be reproduced or transmitted in any form whatsoever without prior written permission from the publisher except in the case of brief quotations embodied in critical articles and reviews.

Contents

Acknowledgements 7
Introduction 9

1. Quakers, Shakers and Penal Reform in New Jersey 11
2. A Most Modern Construction 21
3. The Initial Years: 1811 to 1830 32
4. Executions and Runaways: 1830 to 1860 44
5. It's a Family Affair 58
6. The Wild, Wild East 72
7. Murder Most Foul 90
8. Ragtime and Hard Time: 1900 to 1930 100
9. Depression and Decline 114
10. Stranglers and Cooks 121
11. Too Close for Comfort: 1960 to 1965 128
12. The Prison Museum 138

Notes 149
Bibliography 155
About the Authors 159

Acknowledgements

We acknowledge the enormous effort and dedication that has gone into reclaiming the Historic Burlington County Prison and sustaining it as one of the premier examples of early public prisons in America. The prison rests as the oldest prison of its type and design, and the commitment from the county level and from private donors and volunteers has been the backbone of the effort.

This book would never have been possible were it not for Janet Sozio, Carole Melman and members of the Historic Burlington County Prison Association. The fact that there is a prison museum to write about is due to their perseverance, and the dedication of early members of the association, in preserving this piece of American history and sustaining the effort through the years. We thank Marisa Bozarth, curator of the prison museum, for her knowledge, insight and ability to locate materials and information at a moment's notice.

We thank Larry Tigar and the Mount Holly Historical Society for help in locating and digitizing many of the images used in the book and for protecting the archives of the town and county. We are grateful for the help of Michael Eck and Barbara Johns, of the Mount Holly Library, for getting those hard-to-find documents and publications to us; they were able to locate materials we would have never been able to include otherwise.

We thank our families for putting up with the insanity called "writing a book."

Acknowledgements

We thank Whitney Tarella, at The History Press, for going to bat when times got tough and for never losing faith in the project. Often, she must have felt that we were Michelangelo to her Pope Julius.

Last, but not least, we thank the Burlington County Freeholder Boards, past and present, for continued support of the museum as part of the county's legacy to future generations—and for *not* razing it.

Introduction

The Burlington County Prison: Stories from the Stones emerged as an idea following one of the periodic ghost tours held in Mount Holly, New Jersey. The prison museum plays an important role in those tours, as it is believed to be haunted by former prisoner Joel Clough and has been featured in several paranormal investigations. At the beginning, this was only a ghost of an idea in our heads.

Dave started compiling information for a booklet some years back, but budget and pressing needs elsewhere kept it from fruition. Dennis received innumerable suggestions for another book, not the least persistent of which was his father's urging to write about the people in the prison and in other buildings around town rather than the buildings themselves.

The pending 200th anniversary of the opening of the prison in 1811 pushed the project to the front burner. Frankly, we frequently doubted whether this project could reach its end. The list of candidates for inclusion was large and the information on each relatively scant. Despite some initial delays and difficulty with images and verification of some of the material, it is done.

We thankfully accept that it is done. However, no one effort can ever be the final say on the prison as long as people have an interest in the details and lives of the people who spent time there, whether for a day or for a lifetime. We challenge future volunteers and historians to dig deeper, search the archives and records and compile the stories that emanate from these stones and make up the legacy, large and small, of the people of Burlington County.

1
Quakers, Shakers and Penal Reform in New Jersey

All punishment is mischief; all punishment in itself is evil.
—*Jeremy Bentham*

In presenting stories from the Burlington County Prison, it will be important to understand that the concept of a prison as a place of reform is very new in the scope of history. Punishment, swift and direct, had long been the most common form of managing criminal behavior. In many cases, it was also a way to manage those who were felt to be troublesome, uncooperative or different. An "eye for an eye" and a "punishment to fit the crime" meant different things in different cultures.

A major element of Americans' concept of justice was the punishment meted out in medieval England and the British Isles. Up to the middle of the eighteenth century, punishment such as hanging could be the sentence for a crime as minor as stealing a loaf of bread or poaching in the lord's forest. Branding, maiming (loss of hand or foot) and public humiliation were common forms of punishment. The tradition remained when the American colonies separated from the homeland and became the United States. There was no real concept of reform as we understand it today; nor was there a single event that led to the restructuring of the prison system in America.

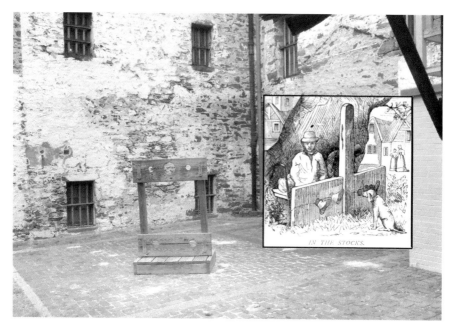

The stocks provided punishment by embarrassment and tribulations supplied by the general public as they passed by.

Managing the "Lower Sorts"

As long as there has been what we refer to as civilized society, with proscribed behavior and legal machination, there has been a perceived need to control those who are outside the law. These might include members of the society who are on the fringe or outsiders who seek to impose their strength or deviancy on members of the group. For as long as there have been outlaws, there have been efforts to control and contain them. From slave galleys and pits and dungeons to death by lions in an amphitheater, society has devised innumerable, often distasteful, methods of curtailing criminal behavior.

In addition, criminal behavior has had many definitions.

For centuries, European and then colonial American civil authorities attempted to differentiate between the *deserving poor*, whose distressed situation was no fault of their own and who merited charitable assistance, and the *undeserving poor*, who were responsible for their condition and required discipline and subordination.[1]

Gaols, asylums, almshouses and workhouses served to house a wide range of individuals for most of the seventeenth and eighteenth centuries. However, the

majority of those in the prison or workhouse were not there for committing crimes. More often, they were there for an assortment of antisocial activities loosely defined in the criminal codes. These included vagrancy, indebtedness, mental illness and insubordination (such as running away from an indenture). The situation in Philadelphia at the time is a good example, since the early Burlington Prison acquired a large part of its philosophy and practice from that found among the Quakers in that city.

Its incorporators intended Philadelphia's almshouse to function as a refuge as well as a prison. For the deserving poor, the almshouse provided shelter and even a rudimentary hospital, a place of last resort where the ill and wounded might recover or die peaceably, where those without support might live and

The poor: deserving or undeserving?

work and from which some might be bound out to serve others. Alternatively, city officials or night watchmen often interned the undeserving poor—for whom the almshouse was a place of correction, even a prison—and a growing proportion of inmates entered in this manner.[2]

Prior to the reform movements of the late eighteenth and early nineteenth centuries, criminals, such as we envision the term today, were dealt with summarily. Justice was swift and sure, if not always fair. At the time of colonization of the American continent, there were at least 240 laws in England that required hanging or decapitation.[3] Public whipping and branding, as well as the loss of a limb or eye, were common penalties prescribed by law. By comparison, even the lowly almshouse was preferable to public castigation, humiliation and possible dismemberment.

The number of executions was relatively low in the colonial period, varied greatly during the Revolution, rose sharply in the mid- to late 1780s and then declined during the 1790s in Boston and Philadelphia but remained high in Charleston. There were also important differences between the cities that influenced the use of the death penalty: the fusion of civil and religious authority in Boston, most visible in execution sermons; a penal reform movement and opposition to capital punishment in Quaker-influenced Philadelphia; and the relations between masters and slaves, as well as the question of dual sovereignty over life by the state and the master, in Charleston.[4]

Gabriel Gottlieb argues that capital punishment was an important tool of social control in early urban America. Executions, in particular, were tools to control the "lower sorts," since the vast majority of those executed were poor, young males.

Executions were especially frequent in moments of real or perceived crisis. The 1780s, a time when contemporaries believed they were experiencing an unprecedented crime wave, saw the highest numbers of executions in all three cities, with a peak late in the decade. By then, the protection of property had become the primary agenda of the death penalty in urban areas.[5]

The Legal Process

American courts were held in rotation and took their tradition from the English practice of having inquiries or hearings completed locally (by the appointed coroner) and then holding the accused in more serious crimes for full trial during the periodic visits by the justices:

Justices of the Court of King's Bench *traveled around the country [England and Wales] on five commissions, upon which their jurisdiction depended. Their civil commissions were the commission of assize and the commission of nisi prius. Their criminal commissions were the commission of the peace, the commission of oyer and terminer and the commission of gaol delivery. By the Assize of Clarendon 1166, King Henry II established trial by jury by a grand assize of twelve knights in land disputes, and provided for itinerant justices to set up county courts. The commission of oyer and terminer was a general commission to hear and decide cases, while the commission of jail delivery required the justices to try all prisoners held in the jails. Few substantial changes occurred until the nineteenth century.*[6]

The pillory was another means of publicizing one's crime, and the punishment, at little cost to the government. Public humiliation was often enough to suppress criminal activity in those who were not destitute, homeless or otherwise "on the fringe."

The criminal spent very little time in lockup, usually no more than was required to await the assizes. As a result, the jail (gaol) was usually relatively small and lacking in amenities required for longer periods of incarceration. On the other hand, inmates were often crowded into the larger almshouses, resulting in overwhelmed personnel.

Prisons held persons accused of a crime for which they would stand trial and, when found guilty, would receive swift and just punishment. The duly punished members of society were then sent home and left to their own devices. Many continued their lives of petty crime simply because there was no alternative for them; no work in their professions and/or lack of training left them without any means of securing honest wages. In this era of "spare the rod and spoil the child" philosophy, those in power required strict control over persons deemed less than desirable.

The "Lower Sorts"

The concept of upper and lower classes is not new, nor is it limited to those societies that have monarchs or inherited leadership. Early America showed a stark distinction between those who were of the upper class (or sort) and those of the lower or middling sorts. (Some might say this trend continues unabated.) Since the Constitution of the United States expressly forbids inherited titles, other ways of establishing social position evolved:

> *It was with their bodies that members of the early national elite displayed material wealth and power, thus demonstrating class and status in the most visible manner. In stark contrast...were the bodies of Philadelphia's vagrants, a general term employed by their betters to categorize lower sort folk whose appearance and demeanor suggested they might be unemployed, homeless, and unable to provide for themselves...As the new republic grew and the ranks of the poor exploded, the prison was reinvented in part to deal with the increasing bodies of more and more socially threatening, impoverished men, women and children. Vagrancy was, quite literally, criminal...embodying both poverty and immorality.*[7]

Society did not refuse alms to the poor or aid to destitute families. However, in keeping with a tradition that seems to remain even today, there was a clear

distinction outlining how (and how much) aid was distributed. All of this was determined by various committees and appointed administrating boards that saw as their duty the maintenance of social stability. The pronouncement of these benefactors concerning the "worth" of the individual often determined the level of care and treatment delivered.

Much of the philosophy about corrections and the purpose of a prison are functions of the social philosophy of the society in which they are established. In the southern Jersey area, the large proportion of Quakers (Friends) with strong ties to Philadelphia meant that the philosophy of those organizations in that city had great influence on decisions made in the surrounding townships. Mount Holly was noted as a Quaker village long before the American Revolution, and Burlington County had at least as large a proportion of Friends as did Philadelphia.

In this regard, Quaker philosophies of equality and the value of work and self-reliance led to reforms in the concept of the prison. This same regard for individual potential in all people led Quakers to promote the movement for the abolition of slavery at about the same time they were pressing for reform in the system of justice. Public discussion centered on the topics of reform and social redress versus punishment.

Joseph Gale was one of very few to observe that "the most afflictive and cumulative distress" in Philadelphia existed among such Philadelphians as "the Irish immigrants and the French Negroes." In this regard, Mr. Gale (a Quaker) was acknowledging that a rapidly growing proportion of the population of the new republic was unskilled, immigrant and generally itinerant labor, as opposed to the well-controlled indentured labor of prior decades. The "French Negroes" he refers to most likely were refugees from the slave revolt in Santo Domingo (and Haiti) in 1791–1806, though there were numerous free blacks and escaped slaves living in the region as well.

In Mount Holly, seat of the prison and courts, there was a large community referred to simply as "Santo Domingo." However, this community consisted mostly of the white plantation owners who fled the revolution in Haiti. This group (which may have included friends or customers of many prominent merchants and politicians, including investor Stephan Girard and financier Albert Gallatin) would have been more likely to seek prison sentences for the poor than to assist them.

The shift in application of the newer principles of reform started with the construction and renovation of the old Walnut Street Jail in Philadelphia. The original design was according to traditional principles: a *U* shape where prisoners lived in common cells. Changes and additions took place

in the latter part of the eighteenth century and into the nineteenth century based on the philosophy of Caesar Beccaria, John Locke and others. The workhouse now sought to teach a trade and provide education for those incarcerated. The theory (still held through to modern times) was that once trained, the criminal would no longer have a need for illegal means of support. The economic and social systems in the new republic butted against this beneficial pragmatism—and still do.

The Basis of Reform

By the mid-eighteenth century, works by reformists arose. Caesar Beccaria's *On Crimes and Punishments* (1764) served as one of the principal treatises for those seeking reform of the punitive legal system. Jeremy Bentham and John Locke publicized the reform movement and lent legitimacy to it. European countries, at least, had begun to look at alternatives to the usual treatment of criminals.

Beccaria addressed the basic assumptions of laws and punishment as they pertain to a just and humane society. His philosophy impressed the English Locke, who influenced many of the political and social engineers of the new American republic:

> *In every human society, there is an effort continually tending to confer on one part the height of power and happiness, and to reduce the other to the extreme of weakness and misery. The intent of good laws is to oppose this effort, and to diffuse their influence universally and equally. But men generally abandoned the care of their most important concerns to the uncertain prudence and discretion of those whose interest it is to reject the best and wisest institutions; and it is not till they have been led into a thousand mistakes in matters the most essential to their lives and liberties, and are weary of suffering, that they can be induced to apply a remedy to the evils with which they are oppressed. It is then they begin to conceive and acknowledge the most palpable truths which, from their very simplicity, commonly escape vulgar minds, incapable of analysing objects, accustomed to receive impressions, without distinction, and to be determined rather by the opinions of others than by the result of their own examination.*[8]

Beccaria espoused positions on each of the typical issues confronting a legal system. He discussed interrogation, the purpose of incarceration, the cruelty of existing prisons and the uselessness of their efforts to curb criminal and antisocial behavior. His position sounds eerily similar to that taken by the Colonial Congress in drafting its Declaration of Independence:

> *Every punishment which does not arise from absolute necessity, says the great Montesquieu, is tyrannical. A proposition which may be made more general thus: every act of authority of one man over another, for which there is not an absolute necessity, is tyrannical. It is upon this then that the sovereign's right to punish crimes is founded; that is, upon the necessity of defending the public liberty, entrusted to his care, from the usurpation of individuals; and punishments are just in proportion, as the liberty, preserved by the sovereign, is sacred and valuable.*

Beccaria's ideology, discussed by philosophers and political leaders in America, led to a revision of the traditional British approach to managing criminal behavior and the "lower sorts." Reformers in America took the principles to heart before those in Europe did. This resulted in an American concept which called for reform of the criminal rather than the application of arbitrary and increasingly onerous punishments:

> *The informal jail of the colonial era gave way to a highly ritualized regimen within a prison regulated by strict, written rules and regulations. No longer were the bodies of prisoners restrained by pain and shame; rather, prisoners were refashioned as productive republican citizens through the well-regulated reformation of their bodies.*[9]

The availability of Beccaria's treatise in English, in America (as witnessed by the 1778 publication date), was an important focal point for the prison reform movement.

> *That a punishment may not be an act of violence, of one, or of many, against a private member of society, it should be public, immediate, and necessary, the least possible in the case given, proportioned to the crime, and determined by the laws.*[10]

Initially, through establishing almshouses and workhouses for those who were the deserving poor, it evolved into the concept applied in the design of

the Burlington County Prison—that the prisoner should be afforded dignity but should be required to reflect upon his crime and be provided with the opportunity and means to attain meaningful and honest employment upon release. As will be seen, this last goal became virtually impossible to attain within the legal parameters of the county jail system in New Jersey.

The Burlington County Board of Freeholders needed the Burlington County Prison to be a short-term facility close to the court to replace the existing jail in Burlington. Its purpose was to hold prisoners awaiting trial, and those condemned to death. However, in an era before social safety nets, it also became a convenient repository for many of the lower sorts in the county; the indigent, mentally ill, vagrants and recalcitrant servants. The evolution of the prison's functions followed suit.

But first, the theories of Caesar Beccaria, Jeremy Bentham, Ben Franklin and John Locke were put to the test.

2

A Most Modern Construction

The only purpose for which power can be rightfully exercised over any member of a civilized community, against his will, is to prevent harm to others. His own good, either physical or moral, is not sufficient warrant.
—John Stuart Mill

Architects design from at least two perspectives: imagination and practicality. The Burlington County Prison was a commission of practical proportions that offered architect Robert Mills a chance to incorporate imaginative penal reform of the time. Classically trained, mentored by Benjamin Latrobe and influenced by Thomas Jefferson's new republican ideologies, Mills wanted to imbue his works with populist sentiment and utility.

The work of Robert Mills on this prison is significant since it represents one of his first public works projects. It set the stage for his belief that design and public function need to reflect social and political issues as much as engineering requirements.

The Burlington County Freeholders wanted a practical prison that did not cost too much. Mills delivered from his end, receiving a paltry $150 for his work. The committee formed to build the prison did not deliver. As we shall see, the construction of the prison ran into issues we think of as happening only in our own time: cost overruns and committee bickering. It would seem that this has been a long-standing tradition among New Jersey public projects.

A New Gaol

Mount Holly had served as the county seat of Burlington County only since 1796. In 1807, the freeholders determined that there should be a jail constructed and ordered materials collected: The county prison was located eight miles away and the officers of the court were tired of dragging prisoners back and forth between Mount Holly and Burlington City when court was in session. Besides, it was costly. For example:

> *May 9, 1798—Freeholders appropriated £56 to construct a small room in the cellar of the courthouse for holding prisoners during court sittings.*
> *May 8, 1799—Sherriff billed the freeholders £1.10 for "wagons and horses for 2 days to convey prisoners to and from the court house."*[11]

At the time, a pound had a value of about $5.30 U.S. In present terms, that would be about $95.00. So the cost of transporting a prisoner would have been $104.50 in today's terms—not that significant, considering the cost of fuel and guard wages today. On the other hand, the cost of constructing the holding cell in the new courthouse was $296.80, or about $5,340 in today's terms.[12]

By the terms of "An Act to Establish Workhouses in the Several Counties of This State" (February 1799), the New Jersey legislature set the responsibility for building and supporting prisons with the county freeholders. This law gave the mandate and authority to the county to maintain its prison system. The Burlington County Freeholders pursued the project by establishing committees.

In 1807, the freeholders (the board that in other states is called the county council or county commissioners) determined that a jail should be built in Mount Holly and named two commissioners to buy a lot and purchase building materials:

> *Resolved that John Bispham and Daniel Newbold be appointed commissioners to contract for and procure materials for the purpose of erecting a workhouse and jail in the town of Mount Holly and the sum of $2,000 is appropriated to effect the same.*[13]

On August 10, 1807, the commissioners reported that they had purchased the lot adjoining the courthouse, built in 1796. The commissioners in charge

of buying building materials reported that they had done nothing and asked to be discontinued. That afternoon, the board accepted the lot, appointed a five-member committee "to draft or procure to be drafted a plan of the said Workhouse and Jail and also to make an estimate of the probable expense of completing the same." The board also named a committee of two "to procure stone, brick, plank and such other material as they may deem proper for erecting said Workhouse and Jail and the sum of One Thousand dollars is appropriated."

On May 18, 1808, the committee appointed to procure building materials reported that it had purchased some and would continue. The committee to procure a plan reported no further progress. One member who declined to serve and another who had died were replaced:

> *The committee appointed to procure a plan and estimate of the probable expense of erecting a workhouse and jail in the town of Mount Holly report that they have made no further progress therein and that one of the committee was deceased and another had declined acting therein.*[14]

Also in 1808, Commissioners Bispham and Newbold completed the acquisition of a lot and reported that they had arranged for some of the materials as directed. However, it would appear that there was still no plan for the construction of the building.

In February 1809, the committee to have a plan prepared reported, "The design of A Building, shewing [sic] the Dimensions the Materials and the Manner of finishing the same." The report included a brief description of Mills's plan, and a cost estimate of $10,000:

> *The committee appointed by the Board to procure a plan of a gaol [sic] and workhouse to be built in Mount Holly for the safekeeping of prisoners report that they have executed said commission and are ready to present the design of a building.*[15]

The board continued collecting the materials and funds required to build the new prison. The entire process would take almost three years to complete, from concept to opening. The result was one of the most up-to-date facilities in the country. In fact, the design and prison policies (along with those of Eastern State Penitentiary in Philadelphia) became the international model of the nineteenth century.

THE BURLINGTON COUNTY PRISON

ROBERT MILLS: AMERICA'S FIRST HOMEGROWN ARCHITECT

Robert Mills was America's first native-born and native-trained architect. At the time (1790), all architects (and many other professionals) went to Europe to study. Mills learned his trade by reading the books his brothers sent home from their studies in Europe. Truly home-schooled, Mills did learn through what amounted to an apprenticeship. He was fortunate, through family and business connections, to learn his trade while working with two of the best designers and builders in the country.

In 1803, while working with James Hoban on buildings in Washington City, Mills drew the attention of President Thomas Jefferson. Jefferson asked him his opinion on certain aspects of the president's design of portions of Monticello. Mills impressed Jefferson with his grasp of structure and function, and the president incorporated some of Mills's ideas in the final draft. It was through this connection that Mills entered the services of architect/engineer Benjamin H. Latrobe. With letters of introduction from Hoban and President Jefferson, Robert Mills began practice in 1805 in Latrobe's engineering and design company. Among other projects, Latrobe was responsible for the interior of the U.S. Capitol Building.

Robert Mills met, apprenticed and worked with architect and builder James Hoban in his native South Carolina. Mills's older brothers studied formally and sent home their architecture and design books, from which Mills obtained his first education. *Prison Museum Association archives.*

Mills would go on to have a most distinguished career. Virtually every major city on the East Coast has examples of his Greek Revival–style architecture. He is noted as a designer of public institutions, churches and monuments. Mills designed a new a set of wings that were added on to Independence Hall in Philadelphia in the early 1800s, after the prison was built, replacing the original wings. These wings, in turn, were demolished in 1898. Perhaps his most famous building is the Washington Monument in Washington, D.C. He also designed the U.S. Post Office, U.S. Patent Office and U.S. Treasury Buildings.

Mills arrived in Mount Holly via a long road of personal acquaintances. Mount

Holly was the country home of Isaac Hazlehurst, Latrobe's father-in-law. Shortly after Latrobe and Mary Elizabeth Hazlehurst were married in 1800, they lived at Clover Hill, Hazlehurst's Mount Holly estate, while Latrobe worked on projects in Philadelphia.[16]

Latrobe was an early proponent of humane penology. In his plan for the Virginia State Penitentiary in Richmond, he provided single cells that opened onto a covered arcade, a feature far removed from the airless rooms of older prisons. His ability to translate social theories into a new building form had a significant impact on his students, including Mills. Mills continued under Latrobe, managing projects in Philadelphia (such as the construction of the Pennsylvania Bank and the William Walker House) while Latrobe focused on Washington City.

In 1808, Mills struck out on his own from a base in Philadelphia. Latrobe's wife was from the Hazlehurst family of Mt. Holly, and it is possible that through this connection Mills learned of the Burlington County freeholders' desire for a new jail. The museum staff believes this may be how Mills came to design the jail.

The Mt. Holly prison was one of Mills's first projects as an independent architect, and his first public building built from his personal design. The prison is a fine example of Mills's ability to identify and solve some of the most difficult structural, safety and utilization problems of the day. It is one of the first fireproof buildings in the United States and was at the forefront of prison design and reform.

Designing the Future

The rational aesthetics of Mill's mentor strongly influenced him. During his work, he corresponded with Latrobe, who shared his opinions on psychological and economic factors implicit in prison design. Latrobe believed that the two leading objectives of a penitentiary program were: 1) the punishment by confinement and employment of offenders; and 2) the restoration of these offenders—reformed to become useful in and to the community—to society when their periods of punishment expired.[17]

In 1807, prior to submitting his proposal for the Burlington County Prison, Mills completed a design for a state prison for South Carolina. He hoped this project would allow him to stay near the home of his new wife's family. He lost the bid for that project, but retained many of the concepts and ideas put into the design.

The Burlington County Prison

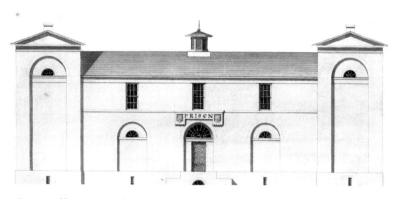

Front elevation (first iteration), Burlington County Prison. As originally designed, each cell was to have a fireplace for warmth and a high, narrow window for ventilation. *Mills Proposal Book, image courtesy of Mount Holly Library.*

Latrobe's thoughts were extremely influential on Mills, and Mills put them into practice in his model for the Burlington County Prison. Mills was a bit of a philosopher and sociologist. His discussions with Latrobe and Jefferson (and others) gave him some heady ideas about how public institutions should function in the new egalitarian republic of America. The almshouses and hospitals of early Boston, Philadelphia and New York had tested new ideas about managing the "lower sort" and the "deserving poor." Still, the concept of a social function for prisons was unique to America at the time.

As noted in the first chapter, jails and prisons of this era (1810) and earlier were often true dungeons—no light, no heat, no washing facilities, no ventilation. The stench of prisons was oppressive, even in eras when personal hygiene was lacking for most people. Disease was rampant. All prisoners, regardless of the severity of their crimes, lived in communal pens or rooms and were fully expected to fend for themselves for food and clothing.

Mills attempted, in his design, to remedy this situation with the overriding principle that an inmate would respond better to dignity of treatment and focus of purpose than to punishment and torture. He followed the principles of Latrobe, who had drawn heavily on Beccaria, Locke and the Quaker prison reforms started at the Walnut Street Jail in Philadelphia. Mills stated these principles directly in his proposal to the Burlington County Commissioners:

> *Gentlemen: In submitting the designs which accompany this for your building I would beg leave to indicate a general view of the principles on which prisons should be instituted.*

> *First as regards Strength and Permanence: When we speak of a building for the confinement and safekeeping of persons we naturally appreciate the idea of durability and strength.*
>
> *Where so much carelessness and malicious wickedness exist, as are to be found in a prison, and where the safekeeping of the persons is of so great importance every practicable method should certainly be adopted to prevent the bad effects of the former and to insure the reality of the latter. Therefore, there should be as little combustible materials used in its construction as possible. Every room should be vaulted or arched with brick as well as all the passages of communication.*[18]

The prison was evolving in this design. That it should be clean and safe for the persons kept there was a new concept only recently employed in the Walnut Street Jail and in jails in Virginia. Mills followed Latrobe's principles when he designed a fireproof building with an internal ventilation system. He also specified the rationale for the design:

> *Second: On the plan or convenient arrangement of the prison. As regards this I would refer you to the following designs. These according to the limits allowed being founded on principles which in theory and practice are known to be just.*[19]

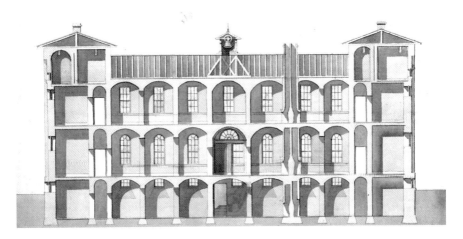

Front elevation, Burlington County Prison. Interior view of the cells showing the distribution of keepers' apartments and cellblocks off the central corridors. *Mills Proposal Book, image courtesy of Mount Holly Library.*

Here, Mills is referring directly to Beccaria and Locke. The concept that there should be a "just" design for a prison was radical. Heretofore, very little concern had been given to the conditions of the jails or inmates; after all, they were lower sorts, criminals and anathema to good, stable society.

> *First. That all the apartments are vaulted and the floors of these paved with brick that are not used as sitting or sleeping rooms.*
> *Second. That the cells or dungeons are secured with a lining of oak plank rendered impenetrable by being filled with scuppers nails.*
> *Third. That the sleeping rooms are of such dimensions as befit them for the accommodation of Only One person.*
> *Fourth. That the windows and doors are of a size just sufficient for the purpose intended; the former raised so high above the heads of the prisoners as to prevent their looking out, which size is in favor of security and economy.*
> *Fifth. That the apartments of the debtors are more spacious admitting of the accommodation of several in one room and possess of* [sic] *superior privileges to those for the common felon.*
> *Sixth. That a complete distinction or separation is made between the debtors and common felons.*
> *Seventh. That the situation of the keepers apartments gives him an opportunity of overlooking the most material parts of the building.*
> *Eighth. That the passages of communication being general, one watch may suffice to guard the whole building.*
> *Ninth. That there is a free circulation of air through all the apartments.*[20]

Mills insisted that there be light. Each cell had a barred window, even the maximum security, solitary confinement cell. Previously, the tradition had been for maximum security and the dungeons to have no access to the outside.

Also, a fireplace heated each cell, except for the maximum security "dungeon," second floor, center. Heat for prisoners had long been considered an extravagance unbecoming their station. Mills allowed for the comfort of the prisoners in keeping with the principle that they, thereby, would be more likely to be rehabilitated and returned to society as productive citizens. They could not do this if they froze to death. To answer concerns about combustibles, the fireproof materials used were stone, brick floors and oak-plank doors reinforced with iron plate.

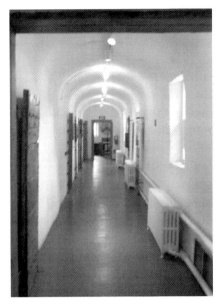 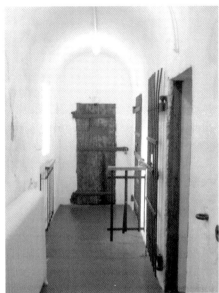

Above, left: The arched design, unique for the period, was drawn from Mills's experience in designing pulpits for churches. *Author photo.*

Above, right: Corridors and cells that locked independently were a unique design spawned by the belief that the prisoner should be penitent and reside in solitude to reflect on his (or her) crimes. *Author photo.*

Mills designed the cell layout to allow separation of the convicts according to the severity of their crimes. He introduced the concept of the cellblock for intermediate felons. These consisted of clustered cells, which fed into a common corridor. Keepers could lock the corridor, and each cell, independently.

The arched design of the ceilings allowed for any sound to reverberate and travel throughout the structure. Supposedly, this would allow fewer keepers to watch over the silent meditation required of prisoners in the new design of jails.

The maximum-security cells were to be placed on the upper floor rather than in the basement. This placement, Mills believed, was more secure. Finally, Mills demanded that debtors be kept entirely separate in large common rooms where they could enjoy a greater degree of freedom.

Debtors were regular tenants of the prison. Their families may have accompanied them, in the manner described by Dickens in *Little Dorritt*, though there is little extant evidence of this at the Burlington County Prison.

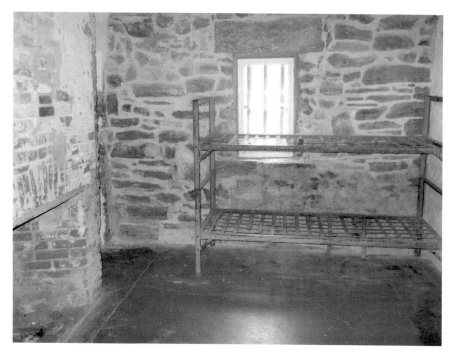

Barred windows were open to the outside to provide air. The layout shown is typical of the initial design of larger cells. *Author photo.*

When the debtor was evicted from a business or home, the family would be left destitute and on the public dole. In many prisons of the era, it proved much easier and cheaper to situate them together in one place.

Such strict adherence to settling debts apparently did not apply to the county freeholder board.

PAYMENT RESERVED

> *Charles Ellis from the committee appointed to procure a draft and estimate of a jail and workhouse in the town of Mount Holly produced an account from Robert Mills, architect, for sundry designs and estimates of erecting said building amounting to three hundred dollars which the Board refuse to allow and thereupon Mr. Ellis is appointed to confer with Mr. Mills on the subject of his*

account and to pay in full of his services any amount not exceeding one hundred and fifty dollars if he will receipt that sum.[21]

The committee to procure a draft reported in February 1810 that it had paid Mr. Mills the sum of $150. From reviewing the other work Mills did and issues encountered when he worked for Latrobe, it appears that such dickering over cost *after the fact* was not unusual for government work. Modern public projects often contain cost overrun provisions, which usually end up costing the government more than anticipated rather than less.

The materials and construction of the jail cost the county $25,000, a princely sum in those days. Of course, in a practical consideration, the board wanted to recover some of this cost.

In 1811, once it no longer needed the old jail, the county wanted to recoup as much as possible by selling off the materials. Much like the resale of old barn timbers today, this was a common practice at the time. Members sold off the old Friends meetinghouse in town the same way in 1775, after construction of the current meetinghouse. Modern government might take a hint from this approach rather than razing properties and building all new.

Resolved that Charles Ellis, Amos Hutchin and George Hancock be and they are hereby appointed commissioners to sell and dispose of the materials of the old jail in Burlington and the lot on which it stands…Resolved that Charles Ellis, William Irick, Samuel J. Read, John Evans and Caleb Newbold be a committee to draft rules and regulations for the government of the jail and workhouse and to present the same to this Board at their next meeting.[22]

The jail was now ready for the inmates.

3

The Initial Years: 1811 to 1830

At what period of her early life the little creature began to perceive that it was not the habit of all the world to live locked up in narrow yards surrounded by high walls with spikes at the top, would be a difficult question to settle.
—*Charles Dickens,* Little Dorrit

The New Jersey "Act for Establishing Workhouses" also spells out the process for commitment and for sustaining the costs of the prison. For the most part, state law allowed county officials and judges to determine the conditions under which they remanded someone to the facility. Generally, this complied with legal precedent and practice regarding the terms of sentence for various crimes. Occasionally—more often than anticipated—officials kept persons in the prison simply because there was nowhere else for them to go.

The prisoners of the initial period of the Burlington County Prison were much the same as those from before its construction. Vagrants and runaways, posing a threat to the stability of the economy, stayed in jail pending trial and resolution of their statuses and circumstances. Those accused of assault, burglary and murder, posing a threat to the stability of society, graced the corridors regularly. A third group, the debtors, made up a separate section of the prison and were, perhaps, the last holdovers from the British legal system of colonial days.

The change in the view of indebtedness came with the growth of industrialization and a monetary versus barter economy in the new

republic. Debt was always in place in America; it was an accepted part of business. However, there was a distinction made between debt for business purposes and that incurred by individuals for their own purposes. Indebtedness took the great and the small. Robert Morris, financier of the revolution, spent three of his later years in jail as a debtor.

Workhouses.

1. Board of freeholders authorized to build.
2. To have government of.
3. Who to be sent to.
4. Materials, how furnished.
5. Servants may be sent to.
6. Who to pay for their food.
7. Duties of masters of workhouses.
8. Persons escaping, how further punished.
9. Accounts to be kept.
10. Penalty for neglect.
11. Two counties, etc. may unite.
12. Courts of other counties may commit to.
13. Duties of master of such another workhouse.
14. Freeholders may convert part of jail into a workhouse.
15. Charge of jails in Essex and Hudson to be in board of freeholders.
16. When sheriff not responsible for escape.
17. Persons arrested on capias, how discharged.
18. Board of freeholders to appoint jailer.
19. Jailer to be master of workhouse.
20. Rules for management of jail.
21. Persons under twenty-one may be sentenced to for term of years.
22. May be sentenced to from other counties.
23. This act may be adopted by other boards of freeholders.
24. Persons from another county to be transported to jail in Hudson and Essex in twenty days.
25. Rates for keeping such prisoners.

An act for the establishment of workhouses in the several counties in this state. Rev. 443. R. S. 619.

Passed February 20, 1799.

1. That the board of chosen freeholders of every county in this state are hereby authorized, whenever they may think proper, to build or purchase a workhouse, at such place in the county as the said corporation shall think fit.(a)

Board of chosen freeholders authorized to build or purchase workhouse.

2. That the said workhouse shall be under the direction, superintendence, and government of the said corporation, who are hereby authorized to appoint and hire some fit person to be master of the said workhouse, and other officers and servants, if necessary, and to make such regulations, ordinances and by-laws, relative to the well ordering and governing the said workhouse, and keeping the persons confined therein to labor, and the manner of their being confined, and relative to the due execution of this act, as they shall from time to time deem necessary or convenient, provided the same be not contrary to the constitution or laws of this state.

To have the government of.

3. That every person sentenced to hard labour and imprisonment, according to the act for the punishment of crimes of other law, for any time not exceeding six months, shall, by the sheriff or other proper officer of the county in which the conviction was had, be delivered to the master of the workhouse, together with a copy of the sentence of the court, certified under the hand and seal of the clerk of the said court, or an order under the hand and seal of one or more of the justices of the peace of the said county, by whom the said sentence may be imposed and shall be there received and safely kept to hard labor by the said master, agreeably to such sentence, and if he be fined, as well as sentenced to hard labor...

Who to be sent to.

4. That all disorderly persons and others, who are or shall be ordered by law to be sent to such workhouse, shall be kept therein at the charge and expense of the county, unless otherwise directed by law; and the said corporation are hereby empowered to procure suitable articles, materials and things for their labor, work and employment; and the money necessary to be expended for the purposes specified in this act, shall be granted and raised by the order of the said corporation, in the like manner as money for other county purposes is directed to be granted, assessed, collected, and raised in and by the act entitled, "An act to incorporate the chosen freeholders in the respective counties of the state."

A portion of "An Act to Establish Workhouses" indicating that the intent was clear from the start that inmates should earn their keep and prison labor would offset public expense. *Author image.*

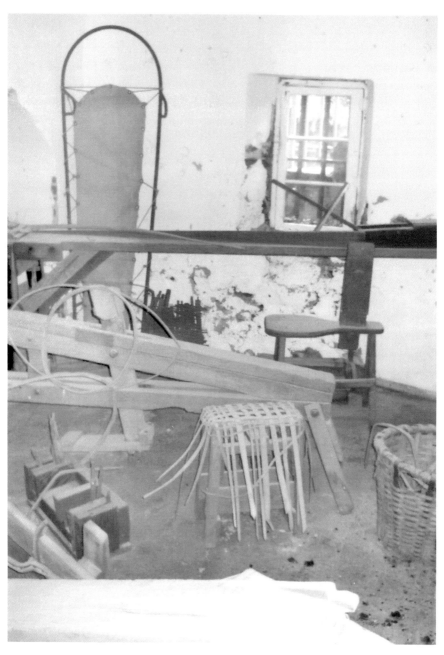

Mills's solution to the problem of debtors was to create, on the ground (cellar) floor, a workroom in which both debtors and felons could make articles such as baskets, brooms and wooden utensils. From there, the items were taken to market and sold, and the money was placed in special accounts for the prisoners. The debtor earned his release when he had earned enough to pay his debt. *Author photo.*

> *Becoming indebted was acceptable. Becoming insolvent was often viewed as proof of indolence or poor character. Until society accepted egalitarian bankruptcy laws, many spent days, months or even years in jail awaiting the opportunity to repay debts or to be released by the courts for reason of insolvency.*[23]

All of these debtors had to be fed and clothed at county expense—unless the county could recover those expenses through letting out the prisoners' labor or having them earn money within the prison workshops.

On the Public Dole: 1800–1820

Philadelphia was the principal port in America, followed by Charleston, New York and Boston. The influx of immigrants and foreign representatives had always made the place very colorful and diverse. As the new republic broadened its business and cultural horizons, it was imperative for those in the "better" classes to ensure that their status remained unchallenged by these newcomers or by those for whom fortune had not been kind:

> *The imprisonment of large numbers of vagrants was in part the result of a late eighteenth century debate about the nature and purpose of the jail in a republican society; a debate that resulted in a series of significant reforms.*
>
> *As the new federal government assumed shape, republican incarceration and punishment underwent a revolutionary transformation...Rather than seizing and breaking the bodies of convicts, the prison assumed long-term control of convicts in general and vagrants in particular in order to set about refashioning them.*[24]

In the legal system, there was a major attempt to equalize the classes. Everyone was equal under the law. The prison served both the criminal and the civil detainee. Those awaiting trial were kept in separate cells from those in debtors' quarters. At the Burlington County Prison, debtors were kept in group quarters, in cells designed for that purpose.

The debtor's status under early American systems was really not much different than it had been under British law. The newspapers were full of public notices from insolvent persons seeking redress from the courts in

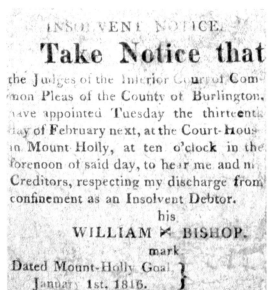

Debtors would publicly apply, individually or as a group, for release from their debts by the courts. The appeal to public conscience was common until formalized laws concerning bankruptcy came about. Mount Holly Herald *archives*.

the form of release from their debts. Until the latter part of the nineteenth century, individual debtors could not bring bankruptcy proceedings on their own initiative. They had to rely on a friendly creditor to file the petition.[25]

The proximity to Philadelphia influenced both the design and operations of public facilities of all sorts in southern New Jersey. This included prisons, almshouses and hospitals. Therefore, conditions noted during the reception of the *deserving* poor at the Philadelphia almshouse can serve as an example of the circumstances of many of those who entered the Burlington County Prison in its early manifestation:

> *Daniel McCalley and his five-year-old son were admitted because he was "an old man and lately much hurt at his work at a mast yard"…the old soldier William Payne was "mostly full of ulcers and sores, yet he works duly in the garden and is very orderly and willing." The poverty of Hannah McDonald—"a sturdy young woman"—and her young child were the result of her husband's imprisonment.*[26]

Once in the almshouse, workhouse or prison, individual lives were at the mercy of the overseers, board of directors or, in the case of the Burlington Prison, the county freeholder board, sheriff and keeper of the jail. Children found begging or otherwise not in purposeful activity, were often indentured

to local farmers or merchants as a means of covering the cost of their care. Families who found their way to the almshouse (and prisons) could easily find themselves split up as effectively as if sold into slavery:

> *Elizabeth Phillips entered the almshouse with two young children in order to escape "the abuse of a worthless drunken husband," but her family was soon split up when the older child was bound out as an apprentice.*[27]

Caring and concerned parents made every effort to avoid entering the sanctuary of society because of the common knowledge that officials were likely to strip children from parents deemed unfit and hire them out. This was typical for the time. Parents were accustomed to apprenticing their children for trades or letting them out as servants or workers during seasonal periods. The difference arose when the prison board or the administration of the facility made that decision, expressly for the benefit of the facility.

That the legislation authorizing county prisons employed the term "workhouse" was in keeping with the new purpose of the prison. The facility was to employ the prisoner in productive labor. Yet, under the law of the state, the prisons were principally for short-term stays. Inmates served any sentence of greater than one year at the state penitentiary in Trenton. Thus, maintaining an industrial activity within the prison became virtually impossible. The result was the extensive practice of hiring out inmates to cover their cost of care, as noted in the following advertisement, which ran in the October 13, 1819 *New Jersey Mirror*:

> *For sale. The time of a black boy who is 18 years of age and has seven to serve—very stout of his age—he is suitable to work either as a house servant or to work on a farm. Call on either James Wilson, Gaoler, Mount Holly, or Amos Ivins, about middle way between the Toll bridge and Moorestown.*

Through the years, the prison population varied, though the jail was never large. The Mills design allowed for assignment of one person to each of twelve small cells, four each to some larger cells and two debtor cells. With one cell in the dungeon (located on the second floor), the jail had a capacity of about thirty-seven persons. After about 1811–14, when work programs were abandoned or modified, the capacity rose to about fifty. The actual population varied from as few as seven in the 1920s to over one hundred in the 1960s.

The Burlington County Prison

What Do We Do With Him?

Mental illness and disability carried as much stigma in 1820 as they do today. We often have the impression that there are more people with disabilities in modern times than in the past. The reality is that in an agrarian society there are many more opportunities for partial or temporary employment for the person who is "outside the norm." As a result, fewer relied on public help.

As it had been for centuries, the prison was the emergency placement resource for those who needed to be removed from society (for their own good or for that of others). For centuries, this meant being tossed in with the rest of the criminal crowd and left to fend for oneself.

In 1799, the county purchased a farm and constructed an asylum and poorhouse:

> *The Burlington County Insane Asylum is located on Pemberton Brown's Mill Road just east of Burlington County College on the north side of the road. The county established its first institution here in 1799 when it purchased the Josiah Gaskill estate, a farm comprising 472 acres. Here the county set up its poor farm and almshouse. The county built the first building there in 1801, a structure to house the poor and indigent measuring 40' x 80'. Workers added a new wing to the building during the mid-nineteenth century.*[28]

In Burlington County, indigent persons from the class of the "deserving poor" generally fared better. Though they may have spent a night or two at the prison, if they were in public trust for any period of time, and not remanded to jail by the courts, they could be transferred to what some might consider better quarters. Those with no criminal action against them might apply to the almshouse, or be referred by reputable citizens. Others were sent by order of the courts.

The county managed the site as an asylum and almshouse until 1920, when a fire served as impetus to rebuild and redesign. Despite this "specialized" setting, the Burlington County Prison remained the place of immediate recourse for many who might be sent elsewhere today. It would appear that most of those held in the prison in lieu of being sent to the asylum were locals, known to the sheriff and others, and were afforded space as a matter of community charity.

As noted, the board of freeholders oversaw jail operations. Meeting minutes clearly state that one John Riley required some care beyond mere incarceration.

Stories from the Stones

It is not shown why he was in the jail, though it is likely he was exhibiting some unacceptable behaviors and there was nowhere else to keep him:

> *May 10, 1816—Ebenezer Tucker, William Reeves and Clayton Newbold appointed to enquire into the sanity of John Riley now in the jail of this county and to report thereon.*
> *February 12, 1817—Committee on John Riley reported that the County had been supporting him in jail but that he had a house and lot in Medford. Freeholders appointed a committee to try to sell the property and reimburse the county.*

It is clear from this that they had no thought of tossing John out of the jail. They were seeking a means of offsetting the cost of supporting him in this setting. That he was a long-term resident is evident from the following obituary, which appeared twenty-three years later in the June 23, 1830 *New Jersey Mirror*: "Died. At the Prison in Mount Holly, on Monday morning last, June 21, 1830, after a confinement of 18 years and about 4 months, John Riley, aged about 56 years."

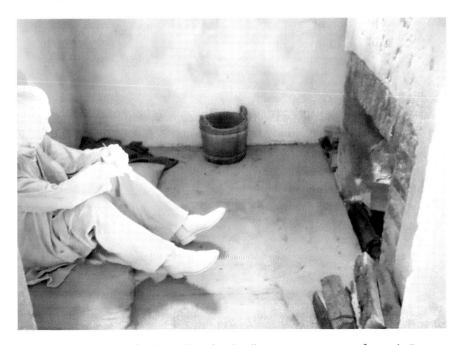

Unique in prison design, fireplaces allowed each cell to maintain a source of warmth. Ducts placed in the corridor ceilings allowed the heat to circulate—not what we would expect in prisons today but an improvement over nothing at all. *Author photo.*

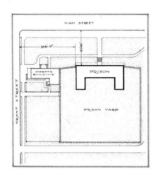 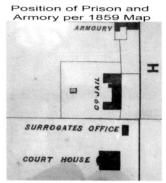

Engineering survey of lot and buildings. The combined 1811 prison plot plan and 1859 map show the proximity of the prison, courthouse and militia armory. In those cases where the militia needed to be called out for service (such as for a notorious prisoner or rowdy crowd), men could be armed literally next door. *Author image.*

How did society address mental illness in 1820? There were no outpatient clinics or treatment teams, as we know them today. The concept of a dedicated facility for treatment and security of people with various mental illnesses did not exist in medical literature, much less in practice. Specialized care was still decades away, when Dorothea Dix and Sigmund Freud would begin exploring treatment. For the time being, people dealt with mental illness much as they had for millennia:

> *Derangement, depression, and mania afflicted rich and poor alike, and just as with illness and injuries, such conditions were often dealt with at home. Unusual behavior and activities were countenanced by family and friends, and allowed by the community as a whole, until a person became violent, dangerous to self or others, or in other ways undermined community norms.*[29]

Maintenance costs were the primary concern of the various systems we might now call social welfare or detention. A cost to the community was expected but should be minimal and should be offset as far as possible by the person's employment or indenture, or by the sale of property (as in the case of Mr. Riley). Society expected family and friends to assist in the care and treatment of the indigent person. Once placed into the facility, family was expected to provide support for the individual.

Various Meanings: "On the Lam" in 1820

The February 3, 1819 *New Jersey Mirror* reported that "on January 31, 1819, two prisoners escaped from the Burlington County Jail. Mr. Wilson, the Jailor discovered the escape."

Mills's "escape-proof" design was apparently not so escape proof. This was only the first of many breakouts over the years, with some ending more successfully than others. News traveled rather slowly in those days. The following reward advertisement for return of the prisoners showed up in the same issue of the *Mirror*:

> *$40 Reward for the return of two prisoners who escaped from the Burlington County Jail on January 31, 1819. Samuel Laning alias Hamlet, alias William Thompson, about 19 years of age, dark complexion, blue eyes and long curly hair; had on a blue roundabout [sic] jacket, grey pantaloons, common fur hat, about 5 feet 5 inches high. The other named Obadiah Reed alias George Sommers about 26 years of age, light complexion, dark hair and large blue eyes; had on a velvet roundabout, blue cloth pantaloons, a fur hat nearly worn out, and a pair of old shoes. Forty dollars for both or twenty dollars for either. James Wilson, Jailor, Mount Holly.*

On May 12, 1819, the freeholders gave the twenty-dollar reward for the capture of Obadiah Reed to James Wilson, the jailor.[30] Apparently, James apprehended Mr. Reed himself, after Reed escaped through a window in the jail. However, it did take three and a half months to do so, indicating the ease with which someone could hide. (Apparently, they never did apprehend Samuel Laning, giving the prisoners a 50 percent success rate.)

Despite the slow spread of news, it apparently traveled far and wide. To fill in their columns, editors in relatively distant publications often cited news from other places; this example included a not-so-subtle remonstration about the abuse of strong liquor. On April 31, 1824, the *Susquehanna Democrat* of Wilkes-Barre, Pennsylvania, reported:

> *Job Powell, of Mount Holly, N.J., has been committed to the jail of that place, on a coroner's warrant, for the murder of Adam Enger. The murderer and the deceased lived under the same roof; both of them had families, and both were habitual drunkards.*

The following appeared in the *New Jersey Mirror* on December 20, 1820:

> TEN DOLLARS REWARD—*Ran away from David Livezey, a German indented servant man, named John Bender—about 35 years old, 5 feet, 7 or 8 inches high, thick and stout made, light grey eyes, brown hair—took with him a blue cloth surtout, coat, coatee and pantaloons, blue and striped waistcoats, brown woolen stockings, mixed colored cotton coatee, a pair of linsey trowsers, a fur hat, black silk and other handkerchiefs, linen and muslin shirts—several German books, a weaver's shuttle, being a weaver by trade, a bamboo cane, ivory head; two pair of shoes, and a pair of boots with large hobnails in the heels and soals, two watches—he usually wears a white ring in one of his ears—plus other stolen articles.*

We learn that this man was a weaver by trade. The fact that he took with him several German books indicates that he could read, at least in his native language. Bender indentured (or sold) his services to David Livezey, most likely in return for passage to America from Germany. Generally, if the indentured person served the specified time, the master provided him with clothing and a small sum with which to start his own business. Indenturing was also a way for a family to "apprentice" a child for education in a trade, though apprenticing and indenturing are not the same.[31]

As a skilled weaver, Mr. Bender would have been in demand within the growing industrial sector of a town like Mount Holly, though he would have had to disguise himself and perhaps move away some distance to avoid being remanded to his master by the courts. That he left before his contract was completed might indicate ill treatment by his master or his intention to start his independent life sooner than he originally planned. We often do not have

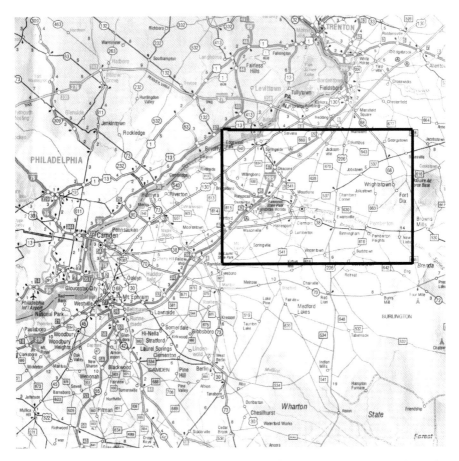

A modern map of South Jersey showing the proximity of the Pine Barrens, Philadelphia and other means of escape. The boxed area is the immediate area of Mount Holly, the Burlington County seat. Burlington County extends about seventy-five miles farther southeast to the Atlantic shore. *New Jersey Department of Transportation map.*

the details on why someone like John Bender left his employer—but it can be interesting to speculate.

As the prison was situated on the edge of what are called the New Jersey Pinelands, also known as the Pine Barrens, Mount Holly's escapees could find numerous hideouts in the barren region. For a distance of at least thirty miles south and east of the town there were only small mills, cranberry bog farms and iron furnaces. Proximity to Philadelphia (eighteen miles) and the seaboard of the Delaware and Atlantic shipping ports meant that an escapee could be almost anywhere within a day or so. In an era before fingerprints and mug shots, there would be little chance of recognition and recapture.

4

Executions and Runaways: 1830 to 1860

Every man got a right to decide his own destiny.
—*Bob Marley*

Crimes committed today receive immediate attention from a battery of reporters and cameras. The stories are told, retold and repeated throughout a community, and even the world, until they have no more significance than a daily cup of coffee. In 1830, crime was certainly well known. The criminals of the day were just as violent and just as dastardly as those we read about today. There were simply fewer of them, and their circle of influence was smaller.

Today, crime is thought of as an urban phenomenon, but for most of human history, it was the rural world that was crime-ridden. Pirates, highwaymen and bandits attacked trade routes and roads, at times severely disrupting commerce and raising costs, insurance rates and prices for the consumer. According to criminologist Paul Lunde, "Piracy and banditry were to the pre-industrial world what organized crime is to modern society."[32]

In mostly rural Burlington County, New Jersey, crime did not favor one location over another or one community over its neighbor. Burglary and theft existed, as did the usual fights and assaults on Saturday night. Runaways, drunks and vagabonds, in keeping with the issue of controlling the "lower sorts," were the most frequent occupants of the county prison. Debtors, too, were common tenants, despite some efforts in Congress to enact bankruptcy legislation. Crimes such as kidnapping, child molestation

> **Great Excitement.** Fall of 1847
>
> ARREST OF THREE COLORED PERSONS.—Considerable excitement was created in our community on Wednesday last in consequence of the arrest of three colored persons residing at Timbuctoo, named Commodore Chase, Aaron Chase, and Elizabeth Brooks, (brothers and sister) by a person from Cecil county, Maryland, who claims them as his slaves. They were taken before Judge Haywood, who, after an examination committed them for a further hearing the next morning. On Thursday Judges Haywood, McHenry and [Do...]ing present, the claimant appeared, with counsel, Messrs. Stratton and Mott—and also the persons claimed, with counsel, Messrs. Spencer and Slack. The result of this hearing was the granting of a trial by jury, to commence this day, (Wednesday).
>
> Since the above was put in type we have learned that David Paul Brown, Esq., has [...]
>
> **Attempt of the Slaves to Escape.**
>
> Immediately upon the rendition of the verdict, Sheriff Collins ordered the Court House to be cleared, and just at this moment the Slaves, both males and female, rushed upon the crowd and attempted to escape—there was a large concourse of persons in attendance and the greatest consternation prevailed. The Sheriff fearing an outbreak among the hundreds of blacks present, called out the National Guards, Captain Forker, to protect him in the discharge of his duty. In the meantime the Slaves were secured and tied—The Guards promptly obeyed the call, and in a very few minutes were on the spot fully armed and ready for any emergency.
>
> The citizens were also called upon to render assistance, and a double line was formed from the Court House to the Jail, and the prisoners under a strong guard were taken to the prison and confined in separate apartments.

Three blacks from the small community of Timbuctoo (near Mount Holly) were detained in the prison, and a near-riot ensued. They were awaiting a hearing on whether they should be sent back South under the Fugitive Slave Act. The ruling was in favor of the plantation owner. *Mount Holly Historical Society.*

and sexual assault existed but were less frequent, or less frequently reported. Runaways posed a regular, if not serious, problem. Laws favored the master over the servant and sustained the position of the employer and landowner over the worker and tenant:

> *The motives that inspired indentured servants to run away varies. Some may have found a half decade of service to another person frustrating or even unbearable; others may have fled from a harsh or unsympathetic master or mistress.*[33]

Still others were runaway slaves or free blacks who feared the possibility of being viewed as runaways. In 1819, New Jersey officially remained a slave state. Though many free blacks lived and worked in or near the various towns, including Mount Holly, the trafficking in humans continued through a network of slave catchers and unconscionable officers of the law. In a letter to the editor printed in the *New Jersey Mirror* in April 1819, the writer opines

> *I submit to the reader the following announcement. "In the Washington paper, April 12, 1819. On April 17th at 3 o'clock, P.M.*

The Burlington County Prison

at the jail in the city of Washington, a negro man named James, by me advertised as a runaway—Ormand F. Butler, Jailor." To my uncultivated notions it seems quite outré *to see a man advertised for sale, at public auction, by an officer of our republican government. When I look at this again, I don't know what to think. I called on one of my neighbors, and asked him about it. He said it was a very common thing for he had often seen such advertisements. I asked if there was proof of his being a runaway, to which my acquaintance answered none was needed. The man was put in jail and advertised as a runaway—but as there is no proof of his being a runaway, or having any master, he is now to be sold to anybody who will buy him, in order to pay the expense of taking him up and keeping him, etc. The expenses must be paid; and there is no way so convenient for raising the money, as selling the man. He had no business to be suspected.*[34]

Anyone with a healthy sense of self-preservation would steer clear of the law in any form. The local pines helped hide many self-emancipated slaves, and the local establishment tolerated sanctuary provided by small black communities throughout the region. The ability of court officers to pursue someone simply because he was suspected of being a runaway slave did not end until after the Civil War, when different, and still intolerable, laws were put into place.[35]

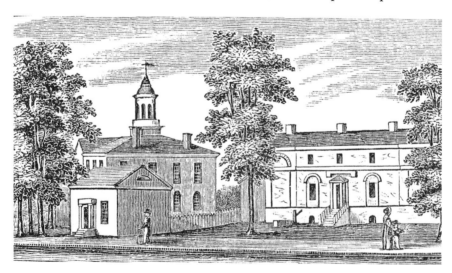

Sketch of the prison from 1825. *Mount Holly Historical Society.*

There was a singular case involving Burlington County (and the prison) that set the precedent for New Jersey's management of fugitives. It also exposed public support for the protection of self-emancipated slaves and free blacks in an era when slave catching and kidnapping of free persons to be sold in the South were rampant:

> *The New Jersey Supreme Court heard* State v. Sheriff of Burlington *in 1836. Petitioners sought the return of an alleged fugitive slave residing in New Jersey. Chief Justice Hornblower's opinion considered the constitutionality of the federal fugitive slave law of 1793 and suggested that the federal government could enforce no part of Article IV other than the Full Faith and Credit Clause. He nevertheless decided in favor of the alleged fugitive, basing his decision on New Jersey's 1826 fugitive slave law.*[36]

In August 1836, the *New Jersey Mirror* reported that it received a certification signed by eighteen residents of Mansfield (near Columbus, New Jersey) regarding the status of Severn Martin, a colored man living among them. He was noted to have lived there for twelve years, and "his conduct and general deportment has been that of an orderly, peaceable, good citizen of industrious and sober habits."[37] The report continued:

> *Martin was decoyed from his home by Constable Isaac Hancock, of Burlington, and was in Weatherill's Tavern, claimed a slave, pronounced such and writers of account were not happy.*

Martin was released, based on the decision of the New Jersey Supreme Court applying New Jersey's 1826 fugitive slave law and thanks to the favor of those abolitionist supporters who pressed for this action and raised $800 to pay for his freedom. Nothing further was found about Martin, though many free blacks and escaped slaves, having avoided being sent south after similar incidents, typically left the area for points north (such as Auburn, New York, or Canada).[38]

The Burlington County Prison

Capital Punishment

Execution, until the revision of the New Jersey criminal code in the 1840s and '50s, was called for in a number of crimes not typically considered capital offences today.[39] Executions in the county prior to 1830 are shown in Table 1.

TABLE 1. PRISONERS EXECUTED SINCE FORMATION OF BURLINGTON COUNTY

Year	Crime	Prisoner	Year	Crime	Prisoner
1718	murder	Stephen Harris	1783	murder	Negress Belle
1738	poisoning	Negro Boatswain	1783	home invasion	Nathan Tomlinson
1738	poisoning	Negro Robin	1784	murder	John Sharp
1753	horse theft	William Bowley	1786	highway robbery	Felix Hammel
1755	burglary	Samuel Anthony	1786	highway robbery	William Mahone
1762	murder	Samuel Stoddard	1787*	murder	John Campbell
1764	burglary	William Hitton	1787*	murder	Patrick Kamen
1764	burglary	Negro Simon	1787*	murder	James Keafe
1765	burglary	John Fagen	1801	murder	Cyrus Emlay
1765	burglary	John Grimes	1832**	murder	Elizabeth Freeman
1765	burglary	John Johnson	1833	murder	Joel Clough
1766	horse theft	Richard Highcock	1860	murder	Philip Lynch
1766	murder	Elizabeth Vaughn^	1863	murder	Charles Brooks
1766	murder	James Anin	1894	murder	Wesley Warner
1766	murder	James McKenzy	1901	murder	Charles Brown
1769	rape	Jacob Shoemaker	1902	murder	John Young
1772	burglary	William Reed	1906	murder	George Smalls
1772	murder	William Smart	1906	murder	Rufus Johnson
1774	rape	Peter Galwin	1915	murder	Griffith Johnson
1774	murder	John Taylor	1915	murder	Edgar Murphy
1780	murder	Robert Pomeroy	1918	murder	Giovanni Iraca
1781	treason	Joseph Mulliner	1922	murder	Louis Lively

^ Only woman executed in the county until Elizabeth Freeman in 1832.
* The year New Jersey modified the criminal code to reduce the offenses for which capital punishment could be sought.
** Subsequent inmates executed while in the county prison. Executions were carried out by the state beginning in 1907.
*** The last prisoners to be executed by hanging in Burlington County were Smalls and Johnson in 1906.

There are four different methods of hanging:[40]

> *THE SHORT DROP—where the condemned is placed on a vehicle (i.e. a horse and cart) or some other object (i.e. a stool, or box) which is then removed, leaving the unfortunate to die from strangulation. In English systems, this form of hanging took place until the 1850s.*
> *SUSPENSION HANGING—instead of lowering the "floor," the gallows are raised in suspension hanging, either working on a*

pulley system, or some other mechanism. The results are largely similar to the Short Drop.

STANDARD DROP—*replacing the Short Drop from the 1850s, this method of hanging, where the condemned were dropped from a height of between four and six feet, was considered more humane as a broken neck would be effected leading to paralysis or immediate unconsciousness.*

LONG DROP—*This variation of the Standard Drop was devised by William Marwood in 1872 and took into account the victim's bodyweight in order to best devise sufficient force to ensure the neck would break. One unfortunate side-effect of the increase in height (sometimes up to ten feet) was that several victims were decapitated as a result.*

All in all, the process was grisly and yet titillating, as evidenced by the large crowds that attended these events. Actually, the current spate of TV reality cold case and autopsy shows probably appeals to the same emotions. In order to avoid the crowds and circus atmosphere, the county began limiting access to those attached to the crime or the trial or those on official business as witnesses. Nevertheless, space in the surrounding treetops and rooftops was limited.

The reform movement to abolish the death penalty is not new. Thomas Jefferson introduced a bill into the newly formed Virginia state legislature. It was defeated by one vote, indicating the support among the public for reform. This bill proposed that only murder and treason be punishable by death.

In the early to mid-nineteenth century, the movement for abolition of the death penalty gained momentum in the Northeast. In the early part of the century, many states reduced the number of capital crimes and built state penitentiaries. In 1834, Pennsylvania became the first state to move executions away from the public eye, carrying them out in correctional facilities.[41] New Jersey followed suit, and capital punishment was limited in use. After carrying out executions in 1833 and 1834 on public land, Burlington County did the same. As a result of this change in public policy, there were few hangings in Burlington County during the early and mid-nineteenth century. Those that occurred were public sensations.

The Burlington County Prison

Murder or Self-Defense?

The first execution of a prisoner held at the new county prison and workhouse was Eliza Freeman. Eliza was a free black living with her husband in what is now Washington Township (Bass River area). According to the reports, both had a problem with strong liquor. The *Mount Holly Mirror* wrote in January 1873:

> *At the May term of the Burlington Oyer and Terminer, in the year 1832, Eliza Freeman, a poor, ignorant negro woman, was tried, convicted and sentenced to be hanged, for the murder of her husband. The Hon. Gabriel H. Ford, then one of the Associate Judges of the Supreme Court, presided at the trial. The trial of this wretched black woman created no such excitement as that of Clough, just one year afterwards, nor did her fate excite any such sympathy among her own sex, since, with the exception of a few Quakeresses, they gave her very little attention. She had been very intemperate, was ignorant and friendless, with only sufficient sensibility to plead to the indictment.*

Eliza has little history other than the reference to strong liquor. What can be gleaned from her status, age and circumstances is that she was a free black (the adopted name is one indication), or at least her husband was. If conditions were typical for them, they were farming land that had limited capacity and were hiring out as day laborers or servants to make ends meet. As with many of the "lower sorts" of the time, of all races and creeds, rum was the self-medication of choice. The *Mirror* article continued:

> *Her husband and herself had been drunk for some days previous to the homicide, and upon the fatal day the husband had lain down on the floor to sleep, and while in this drunken stupid sleep, his wife, from some motive difficult to conjecture, took his razor and cut his throat from ear to ear. When questioned as to her motive, she answered that he had often threatened to kill her; as to regrets, she said she was sorry that she had spoiled her uncle's floor.*

Eliza's indictment reads: "Feloniously, willfully, and of her malice aforethought, did make an assault and that the said Eliza Freeman with a certain razor of the value of twenty-five cents...strike and thrust...a mortal

The indictment paper of Eliza Freeman, 1832. New Jersey Archives.

wound."[42] The need to specify the value of the razor has always been a puzzle, though it was a considerable sum for a razor at that time. Perhaps this was a piece of journalistic license, raising doubt as to the defendant's veracity; or, perhaps it was a means of assuring the evidence in the indictment was readily recognizable in court.

In 1865, a recollection of the execution was written in the *Mount Holly Herald*. It was part of an article on the execution of Mrs. Surrat (one of the Lincoln conspirators). The story at that time, shortly after the end of the Civil War, was less beneficent than later accounts. It also indicates the spectacle afforded the event by the presence of so many military and official persons:

> *At about half-past twelve o'clock, this unfortunate woman was brought out of prison; and rode to the place of execution, (about two miles from Mount Holly), in an open dearborn, attended by Sheriff Hollinshead, and the Rev. Samuel Budd, of Pemberton, accompanied by the Constables of the county and Captain Ridgway's Troop of Horse. The following volunteer companies preceded the criminal and formed a hollow square around the gallows, viz:—The Mount Holly Guards, Mount Holly Cadets, Mansfield Union Guards, Medford Light Infantry, a company*

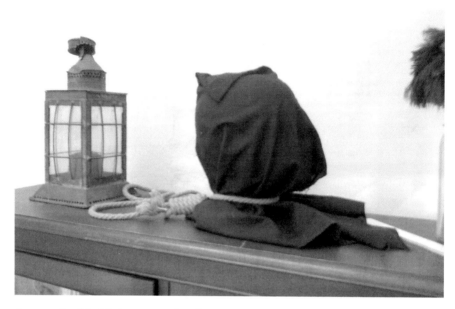

An example of the black covering placed over a person to be hanged. *Author photo.*

> *from Burlington, and a company from Atsion, all under the command of Major William Irick. The number of spectators have been variously estimated from 3000 to 5000.*

The 1873 *Mirror* reporter, someone who had witnessed the trial as a youngster, made comments on social issues and public antipathy that he most likely would not have made prior to the Civil War. The facts that in 1832 New Jersey still had several hundred slaves in ownership, was a haven for both escaped slaves and slave catchers and had a poor opinion of both blacks and the newly arrived Irish did not bode well for Eliza. Society had no deep commitment to addressing the needs of persons who were mentally ill or who acted out of duress, particularly if they were of the lower sort. The *Mirror* article continued:

> *Executions, at that time, were held in public, and it was estimated that five thousand people attended the execution of this poor wretched negro woman. Such was the superstitious prejudice in the minds of people, that the sheriff had great difficulty in obtaining the services of mechanics to erect the scaffold, or the privilege of land whereon to erect it. He finally selected a spot in the highway, about*

half a mile from where the village of Hainesport now stands, on the Mount Holly road.

At the execution of Eliza, she (to the surprise of all) delivered from the scaffold an eloquent address of warning to those around her, cautioning them, above all, to shun the path of intemperance, which she said had led her to the gallows. Upon her bended knees she then repeated a solemn and fervent prayer, not for herself a one, but for all her race, for all who had the care of her during her imprisonment, and also for all those who had been led by curiosity to witness her fate. During all this time a solemn silence reigned throughout the vast assemblage, and she having thus performed the last offices, without apparent emotion, took leave of those upon the scaffold, and the sheriff, having adjusted her cap and arranged the rope over the crossbar, came down to the ground, and turning his back upon the awful scene, gave a sudden pull by a small rope, and instantly, in all that is mortal, Eliza Freeman slept in death. She died without any apparent regret.

The same superstitious prejudice that had interfered with the erection of the scaffold, now exhibited itself to prevent her decent burial. No churchyard would receive her remains, and the sheriff took them to the Alms House burial ground, but the inmates of the institution rebelled, and he was obliged to bury them in a secret place in the night time. Such were people's superstitious notions, even so late as the last generation.

The county paid Sheriff Hollinshead $150 for conducting the hanging of Eliza Freeman. He received $10 for construction of the coffin. As noted, no one would allow the county to bury her in their plots or on their land.[43] The *Mirror* added the following bit of information:

It had been long since any one had been hung in Burlington county, and what appeared strange was that two executions should take place during the Sherifalty [sic] of Joshua Hollingshead. He was a man of fine sensibilities, and these executions appeared to prey upon his feelings, and he never seemed like the same man afterward. He became proprietor of the American House, in Trenton, but failed to make it pay, and died in the prime of life poor and heart broken. Judge Ford remained upon the Supreme Bench until worn out by age and excessive labor.

Joel Clough

Love lost seems to be a recurrent theme in the cases reviewed from the prison history. Crimes against persons tend to be against family, friend, neighbor or colleague. Even then, the type of case seen with Joel Clough is far too prevalent and continues unabated to this day. What would the outcome have been had there been community intervention services? Who can say? Those services exist at the present time, yet as any officer of the law will tell you, the most difficult case is the domestic dispute.

In 1833, Chief Justice Hornblower ruled in the case of Joel Clough:

> *After as full, fair and deliberate a trial as I have ever witnessed in the experience of thirty years of practice at the bar, you have been convicted of the murder of Mrs. Mary W. Hamilton. The final and fatal result has been recorded, and the record speaks while mind and memory and judicial records last, and will continue to speak you—Guilty! And who was Mary W. Hamilton? Was she your enemy? Was it her crime, that beauty had spread her charms and smiled forth in every feature of her countenance...And was it because you could not make such a prize your own, that you resolved in the madness of your heart, she should never live to bless another man?*
>
> *It remains only for us to pronounce the sentence of the law—and it is considered and adjudged that you be taken from hence to the prison of the county from whence you came, and to be kept in close and secure custody until Friday, the 26th of July next, between the hours of 11 o'clock in the morning and 3 o'clock in the afternoon, you be taken to the place of public execution and there be hanged by the neck until you are dead and may Almighty God have mercy on your soul!*[44]

Joel Clough was serious about his ardor for Mary Hamilton, a widow with a child. Joel lived with Mrs. Hamilton and pledged his sincerity, according to his statements.[45]

Joel Clough was not the first to escape from the prison, but he was one of the more determined escapees. Legend says he accomplished the deed by picking the lock on his shackles with a pen and burning the bars of the window with a candle. It has always been a wonder that he was able to weaken iron bars with the heat of a candle. In reality, according to the testimony of Sheriff

Stories from the Stones

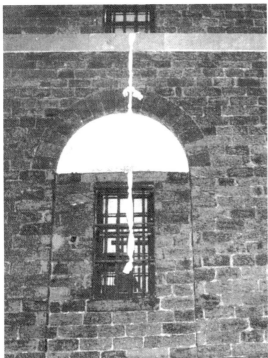

Above: Handcuffs of the type that would have been used to restrain Joel Clough. *Author photo*.

Left: A re-creation of the escape "rope." *Prison Museum Association*.

Hollinshead, Joel burned the wood and plaster window casement encircling the bars and used a saw he made from a spoon to cut through the charred wood. He had been moved into a more commodious, apartment-sized cell from the "dungeon" in order to better meet with ministers and others seeking his spiritual revival. Obviously he had a different kind of revival in mind.

Hollinshead recalled:

> *A candle was allowed him at night, as he appeared desirous to complete some writing in which he was engaged…It was discovered at daybreak on the 21st of July that he had made his escape. He had separated, as it appeared, the chain from his ankle, and forced himself through a narrow passage intervening between the bar of the window and the wall…He then slid down a piece of bed sheet and escaped.*

The spot in the prison yard where researchers believe authorities buried Joel Clough. After the difficulty locating a resting place for Eliza Freeman the prior year, Sheriff Hollinshead apparently made selecting the burial site simple and straightforward. *Author photo.*

Constables captured him as he walked toward Burlington that same evening. The sheriff placed him back in the dungeon under double guard until the trial. Based on the dates of the trial, justice was swift. Clough was executed on what is now the Mount Holly Bypass/Marne Highway; he was brought back and buried in the courtyard of the prison by July 26, 1833. Sheriff Hollinshead got fifty dollars for hanging Joel Clough. Alvin Mills collected ten dollars for providing the coffin.

According to local historians, no one has been able to locate the exact spot where Joel Clough and Eliza Freeman were executed. Hainesport still exists, as does the road to Moorestown (Marne Highway) and the long bridge crossing of the Rancocas Creek. The bypass cuts through the Marne Highway. Perhaps no one wanted to remember the site afterward.

5
It's a Family Affair

And from that hour his poor maimed spirit, only remembering the place where it had broken its wings, cancelled the dream through which it had since groped, and knew of nothing beyond the prison.
—*Charles Dickens,* Little Dorrit

We tend to think of the role of the jail and the courts as curtailing criminal behavior that is a danger to the community. In most cases, only a few feel the effect of the illegal behavior. Protecting the rights and safety of the few is as important a tenet in law as protection of the larger society.

The following appeared in the *Mount Holly Mirror* on January 2, 1862:

> *During the past year there were 168 commitments to our County Jail. Of these 2 (Foulks and Riker) were on a charge of murder; 43 for Drunkenness; 24 Assault and Battery; 22 Petit Larceny, Grand Larceny; 11, Breaking and Entering by night, and by day; 21 as Disorderly persons or Vagrants; 2 for Malicious mischief; 2 for Keeping a disorderly house; and one each for Forgery, Bastardy, Passing counterfeit notes, Incendiarism, Indecent exposure of person, and attempt at poisoning. Eight were bound over to keep the peace, one committed as a Deserter, and the balance as Witnesses and for various petty misdemeanors. Of the whole number, 15 were females, and 23, colored persons.*

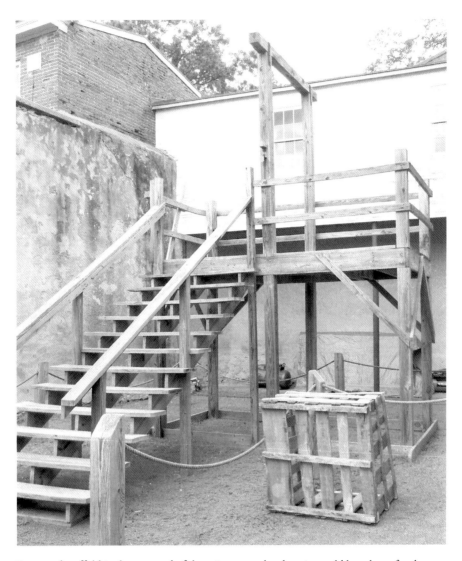

Recreated scaffold in the rear yard of the prison, exactly where it would have been for the executions of Philip Lynch and Charlie Brooks. *Author photo*.

Three cases bring to light the impact of crime on families, even in the past. The prison was host to Phillip Lynch, Charlie Brooks and William Riker. Courts convicted all three men of murder for actions taken in haste—one for love, one in ignorance and the third out of spite. In one case, there was the link often made in the papers to drink and strong liquor. In another, there was restive anger and bigotry toward a family not from "here." The third was a case of familial discord gone awry.

The Burlington County Prison

Phillip Lynch

Phillip Lynch was known to be trouble in his neighborhood. As mentioned in the reports, he was a large, muscular man—a desperate character—and his previous bad conduct and ill treatment of his wife induced her to state to neighbors that she really believed he would commit murder someday. It is noted that he served a year or two in state prison for attempted rape several years prior to this new incident.[46]

George Coulter (noted as "a Scotchman") was regarded as a family man in good graces with his employer, a keeper of the Bonaparte Property in Bordentown.[47] As was usual, the estate manager allowed Coulter to raise his own animals and what extra the man had he would sell for cash. He and his son would walk into town to sell it to one or another of the small groceries there. Town is about a mile from the estate and one passes by the "Murat" homes mentioned in the indictment.[48]

One day, Coulter and his son met Lynch as they were returning home. According to the *Mount Holly Mirror*, Coulter had paused for a "wee dram" at "an Irishman's" store (James O'Kane's at McKnight's Alley), since it was raining and was not pleasant to walk about.[49] The *Mirror* continued:

> *When he reached the row of houses along the Trenton Road, formerly belonging to Prince Murat, and which are occupied by Irish families, he saw a number of persons in one of them and went in. They were engaged in raffling for a watch.*

Here he met Philip Lynch, who insisted that Coulter come home with him for a drink. Coulter had recently become rather attached to spirits and assented. Despite the pleas of his son, he went with Lynch and a man named Peter Conlin. They engaged in some form of arm wrestling or measuring of strength, a contest that Lynch won. Conlin later testified that he "allowed Lynch to win because he was afraid of the man's temper should he not." They proceeded to drink some more, by which time Coulter was pretty well out of it. Lynch had brought down his gun from the upstairs and stood it in the corner of the room—for what purpose was not clear. Then Coulter left to go home, accompanied by both Lynch and Conlin.

The *Mirror* article continued:

> *When about 200 yards from the house Lynch and Coulter got into a fight, which Conlin ended. The boy* [Coulter's son] *became very*

> *much frightened and begged Conlin to take him home. Conlin took the boy home but when he returned he could neither see nor hear anything of Coulter or Lynch. Early in the morning, the dead body of Coulter was found by the roadside, where Conlin had left him and Lynch. Pieces of a stock and the lock of a gun, and the hat of Coulter, were found near the body.*

Despite his protestation that he had neither met nor knew anyone by the name of Coulter, Philip Lynch was arrested. Despite his unwavering statement of his innocence, Lynch's gun served as damning evidence, as constables found its broken pieces under his bed. In addition, blood from where he had washed his boots and a bloody shirt gave him away. The testimony of Coulter's son, James, also put Lynch in a bad light, as it was clear that Lynch occasionally worked for Coulter. The upshot was that Coulter, Lynch and Conlin were all very well known to each other, very drunk and very quarrelsome.

The contemporary newspaper articles described well the evidential work done by the constables. William Holsworth and William Bunting were the officers who arrested Lynch. Holsworth noted that he recognized two hats lying next to the body as those of Coulter and Lynch—an interesting tidbit regarding crime investigation in a small town. Upon searching Lynch's house, the officers discovered the bloody shirt and the broken gun. Holsworth noted that there were "yellow marks on the shirt corresponding with the color of the soil where the scuffle was." Lynch spent three months in jail waiting for the court date, considerably less time than in the present day.

According to the *Mount Holly Mirror*:

> *Lynch was brought into court on Tuesday morning, to receive his sentence. When told by the judge that his protests could not alter the matter, and that the court must proceed with the sentence* [of hanging] *he became perfectly furious, and gave such an exhibition of malignant ferocity and diabolical hatred and revenge as, we believe, was never before witnessed by anyone present...he exclaimed in loud tones, "and may the Devil die with ye."*

The sheriff hanged Philip Lynch in the courtyard of the prison on a scaffold similar to that shown in the photo on page 59. Despite efforts to wrest himself free and pleas that he was innocent, Lynch was convicted, sentenced and executed. In his cell, he made a final plea to the court officers. The *Mirror*

quoted him as saying, "I shall be ready when tomorrow comes—I am ready now." The article continued:

> *He has, since his sentence, disclaimed any ill-will towards anyone but said he wanted to come back, that he might see his little girl—for whom he always expressed a strong attachment. He said, as the only favor he should ask in the other world, would be that he might be allowed to revisit his little girl and he thought it should be granted him.*

It could be argued that Philip Lynch was one of thousands of people who controlled their inner demons with "demon rum." Self-medicating for bouts of mental illness or other maladies has been common throughout history up to modern times, with the abuse of alcohol, laudanum, cocaine and other drugs a common practice well before the twenty-first century. The effects of alcohol—numbing the senses and blinding the memory—would certainly play into Lynch's testimony. Though his particular mental illness was not apparent or identified, the fact that he was a man with a quick temper was obvious, and he was likely less inclined to be generous when under the influence.

Charlie Brooks

Charlie would have been another candidate for modern treatment and social programs. Charlie went on trial for the murder of his father, an accusation he adamantly disputed. In December 1863, the *Mount Holly Mirror* reported:

> *Brooks was born at Vincentown, and at the time of his death, was not quite twenty-three years of age. He was a stout, compactly-built man, about five feet six inches in height, and weighed according to his own account, as high as 165 pounds. He had bright eyes, a ruddy complexion, and his whole appearance was that of one who enjoyed excellent health. He had received a pretty good common-school education, wrote a plain hand, and spelled with general correctness. He usually worked as a farm-hand, but at one time, owned a team of horses and was engaged in carting straw to Philadelphia. Of a pliable disposition, and easily influenced, he appears to have fallen victim to bad company, vicious and depraved*

habits, long indulged—a bad parental example on one hand, and the absence of proper parental restraint on the other.

The "pliable disposition" was apparently not lost on either his mother or his brother-in-law. When it came time to rid the family of the father, Charlie was the obvious scapegoat. When asked to provide a statement prior to the hanging, he blurted out the following:

> *I know that Tim Ridgway and my mother have talked a long time about killing my father. My mother has tormented my father for years. She has been to fortune-tellers and believes everything they say—She believes in witchcraft too. She used to cut pieces off of my father's coat, and cut off his hair. I never knew what it was done for, I never heard her say.*
>
> *According to what the witnesses brought in against me at the Court House, I struck the first blow. I acknowledge it; and that is all I done. Tim Ridgway was at the corner of the lot when I come up. I was drunk. He gave me the club and I knocked my father down and Tim put him out of the way.*
>
> *I have been urged ever since November, 1861, to do this deed. I have been urged by Tim and my mother both. Tim Ridgway is the one that should stand here to be executed. Tim and my mother have talked to me about this affair. Since I was in that prison and had my trial, Tim Ridgway and I talked about this affair. Tim made me believe if I said I knew nothing about it, they would have to give me a new trial. He said there was no help for it.*
>
> *My mother used to write letters to me over and over again, and she has offered me fifty dollars to say she had nothing to do with it. Tim told me to say I was put up by Geo. Hulme and Sheriff Leeds to say what I did before I got back to New Jersey. Tim Ridgway and my mother are the very ones who should stand here—and if justice was done they would suffer instead of me.*[50]

Charlie ran away after the death of his father—at the time, a sure sign of guilt. Yet Charlie's sister testified that her husband, Tim, spent considerable time at the kitchen table at her mom's house encouraging Charlie to run. Burlington County constables brought Charlie back from Salem, in southeastern Ohio. It is interesting that Charlie was traveling west during the height of the Civil War, with troops and battles raging throughout the borderland. Yet this did not seem

to factor at all in curtailing his movement or the effort to catch him. On the way back to New Jersey, Charlie consistently stated that he only struck his father once and then ran away. He told a reporter for the *Mount Holly Herald*:

> *"I struck the first blow. I hit him but once. I threw the stick of wood down, started and ran home and went to bed—but Tim finished the old man." I* [the *Herald* reporter] *said, "who do you call Tim."—"Why," said he, "Tim Ridgway, my brother-in-law." I then asked him how he came to do such a thing. His reply was, that Tim had been at him for six months to do it—and then said, do you remember when the 23rd regiment was at Beverly. It was a month before that, that he first proposed getting rid of the old man—that he has never met him since, by themselves, that he has not broached the subject, and he never gave him any peace, when they were together. I then asked him what Tim's motive was to get rid of the old man. His reply was, to get the property—as he said they could live there to suit themselves.*

In October 1863, at the trial of Charlie's mother, Keturah Ann Brooks, a witness testified:

> *Mrs. B. frequently spoke of her husband, at my house; don't recollect anything serious that she said only about the time she had a black eye; she said her man had hit her; I told her I would sue him; she said if she did she was afraid he would do something worse; remember her once saying something about his throwing a cup of coffee at her.*
>
> *Mrs. Brooks told me about her having her fortune told; can't tell the time—it was in cold weather; said she expected to lose her mother and her husband in the Spring; her mother was to die first. She often talked about Job's running after Keziah Darwood and Becky White.*

Constables arrested Timothy Ridgway based on Charlie's confession. This information was apparently passed to the sheriff as he was bringing Charlie back from Ohio. When deputies went to talk to Mrs. Brooks, they found her surprisingly calm. In the following testimony at her own trial, she clearly states that Charlie was innocent, yet she was nowhere to be seen during his trial a month or so earlier when he was convicted and sentenced to hang:

An early view of the prison with an iron railing. *Mount Holly Historical Society.*

> *Went with Alfred Moore to Mrs. Brooks' house; when she came to the door, Alfred told her they had arrested Timothy and taken him to Mt. Holly; she said, "they have?" he said yes—they have caught Charley and are on their way home, and have sent in for Timothy to be immediately arrested; she replied "you don't say"; she then commenced talking of Charley—said he was innocent—she knew he was; said he was at home and abed that night before nine o'clock and not out afterwards.*

The Burlington County Prison

The following is a transcript of Charlie's testimony at his mother's trial:

CHARLIE: I am a prisoner confined in Jail; I was indicted at the last term for the murder of my father; I was tried and found guilty; my mother was not present when my father was killed; she did not aid or assist in his murder in any way.
ATTORNEY: Do you know who killed him?
I expect I done it.
You did kill him then?
Yes Sir.
Where did you kill him?
At the corner of the lot.
When?
The 8th day of March.
What time?
About a quarter of 9 o'clock in the evening.
How did you kill him?
With a stick of wood and a knife.
How often did you strike him with the stick of wood?
Three or four times.

Here, Charlie contradicts his statements at his own trial that he struck his father only one time. The testimony continues:

Where did you use the knife—in what part of his body?
In the neck.
Have you got that knife now?
I have not.
What became of it?
I throwed [sic] it away on the night of the 9th of March, coming from Pemberton to Vincentown.
When you murdered your father, was your mother present?
No, sir—no one.
You committed the deed alone, then, without any help, did you?
Yes, sir.
What did you do with his murdered body?
Put it down in the ditch.
Did anybody assist you in that or did you do it alone?
I done it alone.

Charlie's responses seem to comply with the image of someone resigned to his fate and eager to avoid bringing his mother into the plot. However, his testimony also contradicts some information provided at his own trial for murder, where there was clear indication that others had convinced him of his guilt. Ridgway's wife, Charlie's sister, confirmed this again in her statement:

> *Charles was at our house the Sunday after the murder, in the morning; Timothy was there besides me and Charles; I knew that Charles was going away from home; heard Timothy persuade him to go away; Charles agreed to go, in Timothy's presence.*

According to the *Mount Holly Herald*:

> *Judge Van Dyke concluded his Charge to the Jury, and they retired at 6½ in the evening. They came into Court about 10 o'clock, on Saturday morning, representing their inability to agree upon a verdict. The Court addressed them a few words upon the importance of the case being decided, and they again retired. At 1 o'clock they rendered a Verdict of* NOT GUILTY.

In October 1863, the county tried Timothy Ridgway for his alleged role in the murder of Job Brooks. He was found not guilty, based largely on the testimonies of Charlie Brooks, who claimed that he alone had committed the deed, and Keturah Ann Brooks, who claimed that Tim had been nowhere near the house on that night. It would seem that, in modern courtrooms, such contradictory testimony would have raised a hue and cry from defense attorneys and rights groups, if not from the courts. Not so in 1863.

On December 17, 1863, the following article appeared in the *Herald*:

> *The gallows (which was the same that Philip Lynch was executed upon) was surrounded by the Union Guards, Capt. Laumaster, of this place (Mount Holly), in the form of a hollow square. Behind "The Guards," were collected some six or seven hundred people—The prisoner took his position on the platform under the gallows, at twenty minutes past twelve o'clock.*
>
> *The Sheriff asked Brooks if he had anything to say. He proceeded to speak in a voice slightly tremulous, nearly as follows: "I stand here upon this platform to be executed for the murder of my father. I have been led to this dreadful crime by Timothy Ridgway. He*

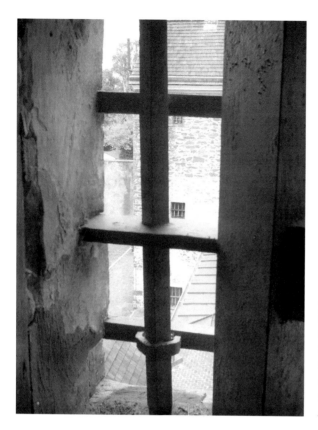

A barred window of the kind found throughout the prison. Over the years, many were fitted with more modern casement windows, but the bars remained on the outside. *Author photo.*

is the guilty man of this murder. They are two guilty rogues, or rascals, or whatever else you may call them, who should stand in my place to-day."

The execution of Charles H. Brooks, for the murder of his father, Job Brooks, near Vincentown, in this County, on the 12th of March, 1863, took place in the yard of the County Jail, in Mount Holly, on Friday last.

It would appear that the execution of Charles Brooks reflected the internal struggles of a family. The testimony from the sister and brother-in-law were in conflict. Mrs. Brooks showed little grief at the death of her husband, and her testimony supported the claim that she and Tim Ridgway encouraged Charles to run out West. With Charlie, the obvious culprit, gone west, they would not be suspects. Mrs. Brooks had ample cause to rid herself of Job and most likely found a willing confederate in Tim Ridgway. It is very interesting, and sad, that a mother would sacrifice her son in this manner for her own gain.

WILLIAM RIKER

Held in July 1861, the trial of William Riker was about the tension targeting immigrants (in this case, Irish). William Riker shot Joseph Williams in a dispute over stolen eggs. The families were witnesses to the event and were involved in the arguments. The fact that the two men had spent a casual Sunday together just a few days before seems to indicate an ongoing relationship gone awry. At this same time, the first major battle of the Civil War was brewing in Manassas, Virginia. It would most likely have been a topic of that Sunday conversation.

According to the *Mount Holly Mirror*, "A man named William Riker, was brought to Jail, on Thursday of last week, charged with killing one Joseph Williams, at Palmyra, in this County [Burlington], the night before [July 10, 1861]."

Riker's testimony was specific that the Williamses, husband and wife, had approached him in a state of drunkenness and accused him or his family of stealing an egg from their henhouse. The *Mirror* article continued:

Riker says he was lying under a tree in front of his house, asleep, on Wednesday evening, about 6 o'clock. Williams and his wife, both under the influence of liquor, came to his [Riker's] house and commenced abusing his wife, charging that some of his family had stolen an egg from them. It appeared that they had placed three eggs under a hen that day and afterwards found that one of the eggs had been abstracted. After abusing Riker's wife, they went out where Riker was lying asleep, with a sheet thrown over him, to protect him from the flies, and began an assault upon him—the woman seizing him by the hair, and the man throwing himself upon his body and beating him with his fists.

Riker arose from the ground as soon as he could extricate himself from the grasp of his assailants, and seized a club, which happened to be lying near, with which to defend himself. The other party were too quick for him, however. They laid hold of the club and wrested it from him. He then ran to his house and got his gun, which was loaded with shot, and came to the door of the house, just as Williams was entering the gate, immediately in front. He raised the gun with the intention, he says, of scaring Williams, by firing over his head. As he did so, his daughter, a girl about 15 years old, cried out to him: "Oh! Papa, don't shoot him." Williams struck the gun down, just as it went off, and the

charge entered his body, killing him instantly. He fell backwards out of the gate. Riker immediately delivered himself up to Justice Wallace Lippincott, who committed him to prison, to await the action of the Grand Jury.

During the trial, Mary Jane Williams, widow of the deceased, testified that she and her husband, Joseph, were harvesting and, when they arrived home, discovered several items missing. Williams accused Riker of breaking into the house, or at least claimed that one of his family members had done so. She stated that Riker picked up a piece of cordwood to strike her husband, but it was wrested from him. She states that Riker and his wife got agitated.

According to the *Mirror* article:

Riker's wife then said, "Go get the gun and shoot him"; he replied, "Yes, the G-d d--n Irish s-n of a b----h, I'll shoot him." He ran in the house, brought out the gun and shot Williams in the right breast. When Riker started after the gun, witness said to her husband, "go away he'll shoot you." Williams said to her, "go home, go home." They had started to go home, she going first. Upon her husband being shot, she seized Riker by the collar: Riker threatened to shoot her; she said, "No, no, you have done enough for once."

Riker stated that he picked up the cordwood to defend himself from Williams, who was pummeling him mercilessly. Riker's daughter gave testimony to that effect as well. The *Mirror* article reported:

Sarah Riker—daughter of the prisoner, apparently about 14 or 15 years old—was sworn. She testified that Williams' wife came to their house, and accused her mother of stealing eggs; that the latter denied it; that Mrs. W. seized her mother by the hair—pulled her upon the floor—called her a damn liar; that she herself went out and aroused her father; lying asleep under a tree, with a sheet over him; that he got up; that Williams and wife both set upon him, knocked him down, got upon him and beat him; that he got away from them—went to the house, they following him; that he brought out his gun—pointed it towards Williams; that the latter struck the gun down—it went off and he staggered back and fell.

The children were witnesses to this carnage and to adults behaving like wild animals over an egg. There may have been previous animosity over some other issues. However, it would appear that this argument stemmed from both families living hand-to-mouth and being jealously possessive of any goods they owned. The *Mirror* continued:

> *From where Riker laid by the fence to where [Williams's] husband was killed, was as far as across the Court Room; Riker stood in his gateway when he shot deceased: deceased fell in his tracks. Witness had her little daughter with her—7 years old. Riker's daughter Sarah was also present. Williams was not inside the gate at all; Riker's wife and daughter stood near him when he shot; the thing occurred between 6 and 7 o'clock in the evening.*

The two children, ages seven and fifteen, were the beneficiaries of a crude lesson from their parents: how *not* to resolve an argument. Today, the county would provide both with counseling and give consideration to removing them from their family homes. In 1861, they fended for themselves. The *Mirror* concluded in October 1861:

> *At 8 o'clock on Saturday morning, the two prisoners—William Riker and Mark Anthony Foulks—were brought in for sentence. Riker was sentenced to confinement in the State Prison, for six years—Foulks for seven. Judge Elmer, before pronouncing sentence, addressed each of the unfortunate men briefly, in appropriate terms. To Riker, he said that in view of the evidence which the Court had had of his previous good character for peacefulness, and in view of the provocation which he had probably received for the commission of the deed of which he had been convicted, the Court were disposed to be more lenient than they would otherwise have been.*
>
> *The Judge abjured them both to improve the time they would now have for reflection and repentance, and to look for pardon and forgiveness to that Higher Power, who alone can grant full absolution for all sin.*

How many children entered a life of misery and poverty based on an incident of passion on the part of one or both of their parents? How many of these children became "guests" of the prison in years to come?

6

The Wild, Wild East

There is no playing fast and loose with the truth, in any game, without growing the worse for it.
—*Charles Dickens,* Little Dorrit

The migration west started long before Charlie Brooks ran away to Ohio. In fact, Ohio was considered the East. By 1850, most folks were heading to the gold fields of California or to the Oregon Territory. The wagon trains shown in movie westerns were in full swing. The army (led by newly commissioned officers like J.E.B. Stuart, Edward Beale and others) protected these trains. Nevertheless, those left behind were no less "wild" than those who populated stories of the Old West.

"I Do. I Do. I Do?"

Preaching and exhorting the virtues of matrimonial bliss and faithfulness was common in the mid-nineteenth century, and such behavior was expected of "better folk." Wavering and infidelity existed (probably no less than today) on the part of both spouses, but the image of a strong and faithful marriage was the social norm and the social expectation. Yet despite efforts to impose social constancy, there were those who seemed always to wander from the straight and narrow.

In June 1853, the *Mount Holly Herald* reported:

> *A man named Michael Shorden, living in Evesham, was brought to this town a few days since, and lodged in jail, charged with appropriating to himself one more wife than the law allows. Michael formerly resided in Camden county, where it is said he has one "better half," but becoming tired of her, he left the neighborhood, and settled in Evesham, where he "saw a girl that took his eye," and believing in the doctrine that if one wife is a treasure, two must be a large fortune as well as perfect felicity, he took charge of the second one, and by so doing was deprived of both. Many men get into difficulty by taking one female partner—and here we have positive proof upon himself by taking a double portion.*

The word of friends and neighbors, as well as the inquiries of the smitten spouse, was often the only clue to the new life established by a wayward husband. There were no credit card trails or insurance claims to bring someone living a dual life to light. Nevertheless, bigamy was seen in the prison and in the courts. It does not seem as common for wives as for husbands, since women were essentially bound to the homestead, and any activity required by maintaining a second family would be easily uncovered.

HAVE WIVES, WILL TRAVEL

The *Mount Holly Herald* reported the following union in 1853: "In Mount Holly, on the 30th of October, by John Folwell, Esq., Mr. WILLIAM D. BARKER to Miss MARY JANE TAYLOR, both of Mount Holly."

The very same William Barker, a traveling salesman working for the book trade, became a rather unexpected celebrity in town because of some poor judgment on his part.

It would seem that Barker, not unlike many of his sort before and since, determined to dally with the fairer sex. To the credit of his parents or teachers, he realized that it was only proper to take the girl of his fancy to wed. However, he seemed to be oblivious to the error of his ways, considering the public wedding announcement printed in the *Herald*:

At West Creek, on the 27th of October last, by Rev. Joel Haywood, Mr. WILLIAM D. BARKER, of Burlington County, N.J., [wed] Miss EMELINE BOWKER, of Barnegat, Ocean County, N.J.

William Barker, well known in this vicinity as an Agent for Evans' Book Establishment, was arrested in Mount Holly, on Monday last, upon a charge of appropriating to himself more wives than the law allows.[51]

The particulars, as we have learned them, are as follows: The Book Trade becoming somewhat dull in Mount Holly, Barker, a few weeks since, took a trip with his stock, "down along Shore." At Barnegat, he was suddenly smitten with a rather pretty looking girl residing there, named Emeline Bowker, who, after a very loving courtship of a few days, concluded to take him "for better or for worse," and they proceeded to West Creek, where the knot was tied. Barker then sold his horse and wagon, receiving therefore the extravagant sum of $30—started for Freehold, where he took the cars for Burlington, and thence to Mount Holly, arriving here on Monday morning in the first train.

Information having been received in advance of his arrival, of his second marriage and his determination to come home for his Clothing, &c., get a new stock of Books, and then leave for the West, accompanied by his bride, a warrant was issued against him, and he was arrested by Deputy Constable, Benjamin Peterson. Barker had a six-barreled revolver, five of them being loaded, and he made fight, but was soon deprived of his weapon, and taken before Justice Peak for a hearing.

While the Deputy Constable was in search of an important witness and the Justice engaged in examining the law bearing upon the case, Barker effected his escape. He made rapid tracks over the Mount, took the Jacksonville road, and so on to Burlington. As soon as the Deputy Constable learned that his "bird" had taken the "wings of the morning" and flown to parts unknown—perhaps to the bosom of his youthful bride—he proceeded to Burlington, and upon the arrival of the cars for New York, saw his friend coming, with the evident intention of taking passage in them—He at once took charge of him, and brought him to Mount Holly, when he was lodged in jail, to await a further hearing. If the statements are correct, Barker will be committed to await the action of our next Grand Jury.

Brought before the court, as William Barker would have been for his indiscretion of having more wives than the law allows. *Mount Holly Historical Society.*

The preaching of Joseph Smith may have played a role in William's thinking, though he never alluded to that principle. On December 10, 1957, the *Herald* reported:

> *Barker, after being released from the jail in this town, last week, went to Freehold, to see his second wife and make arrangements to go off with her—but his hopes were blasted by his arrest and imprisonment.*

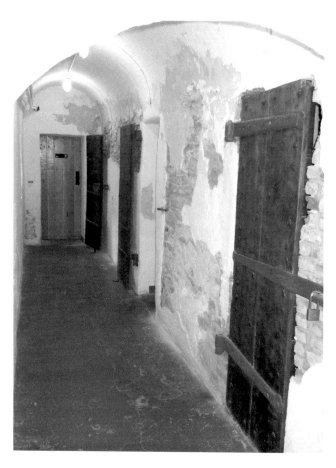

This was not the kind of life William anticipated when he took on wife number two. *Author photo.*

On Friday last he was taken to Tom's River and lodged in jail, to await his trial at the next term of Court. As there are a number of Brigham Young's followers in Ocean County, Barker may be more leniently dealt with than if he had committed the offence in some other section of the State, where the convenient institution of polygamy is not incorporated into the religious creed of the people.

We understand that both wives have turned against him, and they are now as strong in his condemnation as they were previously in upholding and clinging to him. We learn that the last marriage ceremony was performed by Rev. Joel Haywood.

It is possible that Haywood's personal life influenced his willingness to tie the knot between Barker and Bowker without confirming that both were eligible. He was a well-known minister, so mention of his having performed

the ceremony would raise public interest in the story. Journalists are ever vigilant for the hook on which to hang a story. Yet, closet Mormon or not, Haywood deserves some presentation:

> *As a young man, Haywood volunteered to rescue shipwreck victims and to conduct funerals for and bury those who did not survive. Appalled by the loss of life, he joined with William Newell, a member of Congress, to secure support for legislation to establish the Life Saving Service, which, together with the long-standing Revenue Marine Service, became the modern Coast Guard.*
>
> *Haywood married Lydia Pharo in 1821 and they had eight children. After her death in 1842, he married her niece, Mary Ann Pharo, with whom he had four daughters.*[52]

The fact that Mormons (Latter Day Saints) held meetings in Mount Holly may have had an effect on Barker's views of multiple marriages. During the period of Barker's blunder, many Mormons left for Illinois and then for the Utah territory. It was probably the open support of bigamy, and the problems this brought to the general community, that caused Mormons to be castigated and persecuted until they settled in their own "country."

> *The records show that Joseph Smith preached in the state in 1840, as did Brigham Young, in 1843. In 1844, a wagonload of New Jersey Mormons left for Nauvoo, and later, another wagon train left from the state for Utah—all of which indicates that the Church of the Latter Day Saints was reasonably well established in the state, a fact that is not much noted in the religious history of New Jersey. The first record of services in the state dates to 1832, but most of the attempts to organize congregations (stakes, in Mormon parlance), took place in the late 1830s. Mormons established an early stake in 1840 in Tom's River, and other groups held services in Shrewsbury, Recklesstown, Cream Ridge, Greenville, Shark River, Mt. Holly, Little Falls, Pompton, Tabernacle, New Egypt, Jersey City and Newark. But Hornerstown in Monmouth County seems to have been the center for the church, as it is referred to repeatedly in accounts of visits from the church's hierarchy, which at one time included another of Joseph Smith's brothers (William).*[53]

The state tried Barker in Toms River. Apparently the Mormons had already left, along with both his wives. Barker was remanded to state prison and quite

The all-seeing-eye, perhaps drawn by an incarcerated brother Mason but just as easily viewed as the watchfulness of the courts over Barker and his ilk. This is one of many pieces of prisoner graffiti still in place. *Historic Prison Museum Association.*

possibly completed his trip out west as soon as he was released. In 1858, the *Herald* reported:

> *William Barker, formerly of this town (Mount Holly), was tried for Bigamy, at Toms River, Ocean County, last week, and convicted—He was sentenced to the State Prison for six months. He loved not wisely, but two [sic] well.*

Vagrant and Villain—Or Destitute Veteran?

Following the Civil War, life changed immensely in the Garden State and in Burlington County. There was the inevitable recession as war industry closed and new industry was developed. A major economic depression hit in the

1870s, sending many out of work and onto the street. There was no social support then as there is now.

Looking to get back to normal were numerous veterans, home from the bloodiest conflict in American history. Few support groups or associations for these men existed, other than the GAR (Grand Army of the Republic) or Masonic and other fraternal lodges.

Many men joined local militia units as a way to sustain the level of fellowship they experienced in the war. Younger men joined as well, not old enough to have served in the war and not adventurous enough to head out west. Others joined local organizations such as the Mount Holly Cornet Band, the Red Men's Lodge or choral societies—not much different from today.

Such organizations usually based membership on skill rather than status. This, and the common experience of the Civil War, began the process of homogenizing the American population. The middle classes

The Seventh New Jersey Militia, Mount Holly Company, in a nonchalant pose. *Mount Holly Historical Society.*

rose to prominence in the form of merchants and specialty artisans. Mail order catalogues were the vogue, as were combination stores. "Big box" retail entered the era with Strawbridge and Clothier opening their "department" store in Philadelphia. (Clothier hailed from Mount Holly.) These members of society grew wealthy and differed from many who had plied the trades before in that they were now part of the political and social process rather than considered part of the (lower) working class. Indenture ceased altogether as a form of employment, and congregate factories, investors and monopolists emerged as the prime movers of the economy.

Stock speculators and robber barons (such as Carnegie, Gould and Rockefeller) took over industry at the top, replacing landholding plantation owners as the new aristocracy. The exception was in the West, where new millionaires emerged almost monthly from the gold and silver fields and cattle barons lobbied the government for control of large swaths of public land as they fought territorial wars with traditional farmers and new settlers.

By the end of this period, a new wave of immigrants (Italian, Polish and Jewish) would band the Irish and other extant groups together in a united front. The efforts to limit these "aliens" to the lowest forms of labor and employment meant that many of the jobs were those no longer seen as respectable by the second- and third-generation immigrants who came before. Trade unions emerged to protect the best jobs and limited membership to "acceptable" persons.

Blacks, never considered a meaningful part of society unless they rebelled, continued to live on the edges of town and provided transient labor in competition with ensuing waves of newcomers. This economic disparity, as well as latent discrimination and legal bias, provided much fodder for the prison during this period and into the twentieth century.

Poverty continued to be the primary factor in most crimes and indictments. Many families were living hand-to-mouth in what was still a mostly agrarian society. Factory work was available, but many could not make the move to the cities where these jobs existed. Many made their livings as best they could with seasonal work. This meant hardship—and hardship always trickles down in one way or another.

Stories from the Stones

Parental Failure or Zealous Prosecution?

> *May 6, 1875—On Thursday, a jury was empanelled in the case of John Albright and Margaret Albright, his wife, of Moorestown, charged with manslaughter in causing the death, on the 2d of February last, of Frederick Albright, about 10 years of age, by a course of ill-treatment for two years prior to his death. The defendants are Germans in humble life. The deceased was a son of John Albright—the other defendant being his step-mother.*

In the period in question, anyone with a disability or disabling condition was considered less in the eyes of persons without disabilities. Frederick appears to have been a child of limited capacity, at least physically. Examinations by a physician and a coroner concur that he was feeble from the start:

> *The most important medical testimony and very favorable to the prisoners was that of Dr. Stokes, of Moorestown, who saw the child a few hours before his death, and made an external examination of the body after death. His opinion when he saw the child alive, and which was confirmed by the subsequent examination, was that he was suffering from inanition produced by a scrofulous[54] state of the system. He thought the child had been diseased a long time—probably from his birth.*

Pressures on the family from poverty and a general lack of options can bring on maltreatment of those less able to defend themselves. It is easy to scapegoat the incapable, as they are less likely to fight back. The indictment pictures the stepmother as heartless and abusive and the father as unresponsive:

> *The testimony was chiefly to the effect that the child, who was delicate and small of his age, was not sufficiently clothed in cold weather; that he was seen to carry burdens apparently too heavy for his strength; that he was worked hard in picking strawberries in their season; that he was not allowed to eat his dinner at times with the defendants and their other children when picking; that the woman had been known to whip him severely and use foul language to him; that she had been seen to kick him one or two occasions, etc.*

However, the court removed several supposed witnesses because of bias or the prosecution's inability to corroborate their statements. The *Mount Holly Mirror* reported:

> *Scarcely any of the dozen witnesses who testified to the alleged acts of cruelty could give more than one instance as coming under their own observation in the two years covered by the indictment.*
>
> *Judge Woodhull briefly reviewed the testimony and said, in conclusion, that in the judgment of the court it was entirely inadequate to convict the accused of the very serious charge brought against them. Mr. Hendrickson made a short speech. He thought the evidence showed that the defendants had far from discharged their duty as parents to the deceased child—that he had suffered from the want of sufficient food and clothing, that they had at times inflicted upon him cruel and unjustifiable punishment, and imposed upon him labors beyond his feeble strength. Whether these things amounted to the degree of guilt laid in the indictment might be a question.*

The parents were never convicted.

Through all of this change, the prison population still consisted mainly of vagrants, drunks and minor thugs. According to the prison commitment books (available from 1869 on) the colder months saw an influx of vagrants, much like today's "code blue" days. So many were given thirty- to sixty-day sentences that the jail could not possibly have held them all. It is probable that the resultant homeless problem was solved by providing two or three meals a day and a warm place to sleep. Vagrants alien to the county may have been locked up, but those who were familiar sights around the county were probably left to their own affairs.[55]

Regular maintenance kept the prison in shape. Despite several prison inspector reports indicating poor conditions, overall the prison was in barely acceptable condition until near the end of its use. The initial concept of having prisoners work off their keep resurfaced periodically, according to freeholder minutes. The later iteration of this was the road gang, but in-house manufacture of baskets and shoes was common, as was the continued yard work of breaking stone for "macadamizing" roads:

> *Size of stones was central to the John Loudon MacAdam's road building theory. The lower 200 mm road (7.8 inches) thickness*

was restricted to stones no larger than 75 mm (2.9 in). The upper 50 mm (1.9 in) layer of stones was limited to 20 mm size (.787 in) and stones were checked by supervisors who carried scales. A workman could check the stone size himself by seeing if the stone would fit into his mouth. MacAdam believed that the "proper method" of breaking stones for utility and rapidity was accomplished by persons sitting down and using small hammers, breaking the stones so that none of them was larger than six ounces in weight. He also wrote that the quality of the road would depend on how carefully the stones were spread on the surface over a sizeable space, one shovelful at a time.[56]

From that point on, as road building adopted the MacAdam (macadam) method, there was a demand for small aggregate. When exploring the possible work for prisoners, it is hard to imagine a better task than "breaking stone" for inmates with various capacities and skills but strong backs. It was easy to arrange and easy to train the workers.

With the advent of rail travel came those who learned to ride the rails. Given the few years since the Civil War, the rise in vagrancy may have been caused, at least in part, by the condition we now know as post-traumatic stress disorder (PTSD), referred to at the time as "soldier's heart."[57] No real records exist of the number of soldiers who returned home to self-medicate with alcohol and engage in criminal behavior out of desperation or mental instability or whose lives were shattered remnants of what they had been, forcing them to seek shelter with family or friends. It would seem likely that the greater the family fortune, the less likely the returning soldier was to end up in vagrancy court.

Debtors had ceased to be a large portion of the population by this time. Congress passed a Bankruptcy Act in 1867, which changed the population of debtors. As with those acts passed in 1800 and 1842, this one was limited to a five-year life and was intended to protect creditors, allowing only the creditor to petition the courts for redress. Throughout most of the nineteenth century, there was no general personal bankruptcy law in the United States, and most debtors found it impossible to receive a discharge from their debts. Early in the century, debtors could have expected even harsher treatment, such as imprisonment.[58] The latter part of the nineteenth century saw most of these laws repealed or changed in all of the states:

Because control of Congress was split between the two parties for most of the last quarter of the nineteenth century neither side could force through their version of bankruptcy law. This period

of divided government ended with the 55th Congress, in which the Bankruptcy Act of 1898 was passed.[59]

The change in population also occurred because of changes in social policy. With the end of the nineteenth century came the reformers, those seeking to redress grievances and wrongs committed by the large industrial and manufacturing corporations. Sweatshops and the aberrant use of gang labor left a legacy of poverty and despair among newly immigrating families and communities. Unions emerged. Opposed at first and considered illegal or even treasonous, many organizers ended up in jail for disrupting the peace.

Social policy transformation meant alternatives for those traditionally sent to jail. Vagrants and homeless families had shelters—not perfect but not jail. State statutes released debtors from mandatory jail time in 1847 and 1867. Unemployed persons had food banks and assistance in locating work. All of this meant that a different population was doing time in the prison.

Doin' Time

The length of stay at the prison was never more than twelve months, by statute. This fact played a major role in the difficulty of pursuing the rehabilitation approach desired by Mills and others in the design of the prison. Prisoners were supposed to be trained in a trade and then able to support themselves without the need to revert to crime. The short stays, most often for vagrancy or drunkenness, had little effect on the prisoners' personal lives.

Prisoners stated their opinions fairly directly in the song "Hard Times at the Mount Holly Jail." The song is noted to be from the album *Ballads and Folk Songs from New Jersey*, by Herbert Halpert (1936) and sung by Oliver Minney near Cookstown, New Jersey, in October 1936 and several times thereafter. Halpert noted that Oliver did not sing the verses in the same order each time.[60] Sheriff Townsend, named in the tune, ran the prison from 1883 to 1886 and probably had similar affections toward Mr. Minney.

Life in the prison was never more than bare bones; for example, the allotment to feed the prisoners in 1869 was $0.45 per day. The per diem for previous periods was $0.25 in 1837, $0.20 in 1841 and $0.30 in 1861. Straw fill for the beds was used at least up to 1895, when several bales were ordered. Municipal water arrived in 1848, and a library was organized in 1857. (The library consisted of mostly religious tomes donated to assist the prisoners in reflecting on their spiritual improvement.)

Stories from the Stones

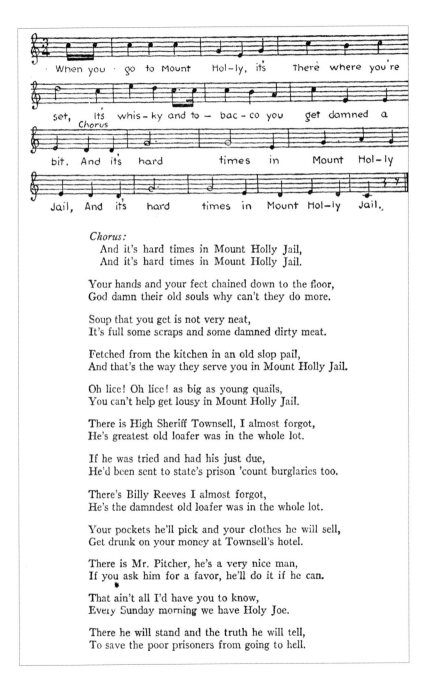

Chorus:
And it's hard times in Mount Holly Jail,
And it's hard times in Mount Holly Jail.

Your hands and your feet chained down to the floor,
God damn their old souls why can't they do more.

Soup that you get is not very neat,
It's full some scraps and some damned dirty meat.

Fetched from the kitchen in an old slop pail,
And that's the way they serve you in Mount Holly Jail.

Oh lice! Oh lice! as big as young quails,
You can't help get lousy in Mount Holly Jail.

There is High Sheriff Townsell, I almost forgot,
He's greatest old loafer was in the whole lot.

If he was tried and had his just due,
He'd been sent to state's prison 'count burglaries too.

There's Billy Reeves I almost forgot,
He's the damndest old loafer was in the whole lot.

Your pockets he'll pick and your clothes he will sell,
Get drunk on your money at Townsell's hotel.

There is Mr. Pitcher, he's a very nice man,
If you ask him for a favor, he'll do it if he can.

That ain't all I'd have you to know,
Every Sunday morning we have Holy Joe.

There he will stand and the truth he will tell,
To save the poor prisoners from going to hell.

"Hard Times in the Mount Holly Jail" brings to light many typical day-to-day events in the life of a prisoner. The song mentions Sheriff "Townsell" in rather unflattering terms. This is most likely referring to Sheriff Townsend. *Mount Holly Historical Society.*

The Burlington County Prison

The Stone Sieve

The post–Civil War editor of the *Mount Holly Herald* loved thinking up nicknames for the county jail: the County Boardinghouse, the Stone Mansion, the County Stronghold, Fort Emly (or current sheriff). However, he missed an equally appropriate one: the Stone Sieve. Despite the building's impregnable appearance, both inmates and county property kept there for their use vanished from the building with some regularity.

There were several reasons for this, not the least of which was the use of soft iron in the construction of manacles and bars. It was an easy descent from the roof to the top of the surrounding wall as a result of the yard wall's aesthetic slope upward along High Street (front elevation). The niches in the yard alongside the building, out of view from the warden's office, provided safe exit points. The large gate, required to allow wagonloads of coal or wood in and refuse out, was a weak link. There were iron tools for the inmates to manage their fireplaces and for the larger furnaces installed in later years; these became very effective weapons. Finally, there was simply too small a staff to provide adequate coverage of all the escape options an idle inmate could concoct.

Stories abound about the ability of prisoners to walk into town, on their own recognizance, to get beer or rum or a bite to eat (if they had funds). The reliance on alcohol within the general population affected prisoners, who had limited access to spirits. As the society changed in the latter part of the nineteenth century, these "allowances" were repealed. It also did not speak well for the policy when several prisoners a year simply walked away and never returned from their respite.

Security was lax, it would appear, because the great majority of inmates were local residents, known to the public and the constables. Longtime county residents, debtors and those with family were likely to be easily located upon escape. Others, in jail for offenses such as drunkenness or assault, were likely to sleep it off at the County Hotel and go home. The authorities would just as soon have had out-of-county inmates, usually vagrants and such, escape and take their upkeep and problems somewhere else.

Occasionally, an inmate got special treatment, as is purported in the following somewhat biased statement. According to the *Mount Holly Herald* (edited by a Democrat):

> *William Kearny, the convicted thief and tramp, who was released from the jail on Monday, by the Prison Liberating Committee, and who was brought to the polls on Tuesday by county officials*

Stories from the Stones

Sheriff Emly and deputies. When the likes of Bat Masterson and Wyatt Earp were taming the Wild West, these stalwart peace officers managed similar characters in Burlington County. *Historic Prison Museum Association.*

> *and made to vote the solid Republican ticket, having first been made drunk that he might most easily perjure himself and cast an illegal vote, was recommitted to the jail on Tuesday afternoon, for drunkenness, at a cost of $5.30 to the county.*[61]

Inmates went out through holes in the roof, filed off window bars, went over the wall on bed-ticking ropes or teetered along the eaves to the sloping wall and the woodpile beside the gate. After 1887, they also had the roof of the warden's house as a route.

The warden's house was added in 1887. Prior to that, the warden and his family, as well as assorted part-time and deputy staff members, resided in the prison. The keepers' quarters were located on the first floor and separated from the prison office and corridors by a stone wall. The walkway (or passageway) from the house to the prison was added to allow for easy communication with the office and prisoners. The added roof offered the inmates another means of reaching freedom.

For most of the nineteenth century, the sheriff and keeper provided daytime security. Since either the sheriff or the keeper lived in the jail, a night watch was seldom called for—escape attempts or riots would awaken him. The prison

hired additional guards on an as-needed basis, such as when a dungeon inmate required a deathwatch to prevent a suicide from spoiling the prospect of a public hanging, the jail was exceptionally crowded or the authorities thought an inmate was a threat to the community and/or a flight risk.

Conditionally Satisfactory

In part, the separate warden's home was prompted by prison inspection reports that the prison was overcrowded and additional space was required.

When they built the place in 1811, the freeholders appointed a committee to look after the management of the prison and workhouse. They were to meet quarterly in the jail to inspect it and hear complaints against the keeper. They were also to purchase tools and materials to keep the inmates employed. It was not until the mid- to late nineteenth century that formal prison inspection teams began to peruse public facilities. A report from the New Jersey Prison Commission in 1916 enumerated the issues facing the use of local and county prisons:

> *First, we have the summary punishment of the offenders, by fining, branding, deportation or death, a system that left little occasion for places of imprisonment—the county jails, which had been primarily instituted for the confinement of vagabonds and insolvent debtors, being also used as places of detention for those awaiting the determination of their guilt or innocence or the execution of the sentence imposed by law. With the gradual development of imprisonment as a method of punishment, the jail, being the only institution available for the purpose, became the place of imprisonment for those condemned to this form of punishment, the result being the indiscriminate confinement, together, of those undergoing sentence and the ordinary jail population. Later, with the overcrowding of the jails, came a recognition of the necessity for separate places of confinement for those undergoing punishment, resulting in the creation of the state prison or penitentiary; and, still later, the recognition of differences of type among those undergoing sentence, causing the institution, one after another, of separate places of imprisonment for youthful first offenders and juvenile delinquents.*[62]

The museum has numerous records of children as young as eight years old being incarcerated for petty offenses. Also, if a nursing mother was incarcerated, and there was no woman able to feed her child, that child came into the jail. The likelihood of the child following in the footsteps of the parent might be fodder for future research.

In 1886, a state inspector visited the prison and wrote a report that would appear to be a classic application of practical psychology. His gently worded criticisms led the freeholders to order cots, install toilets and build a connecting house for the sheriff so that the jail space occupied by his family could be used to house inmates. (It seems the family used the cells nearest the assigned keeper's quarters as the children's bedrooms.) The report read:

> *Sheriff Edward Emly:*
>
> *My dear sir: Permit me, through you, to address the Board of Freeholders of Burlington County. At my visit to inspect the jail on Tuesday last, I found it kept fully up to the average of the jails of the State, and better than some of them. No doubt your Board recognizes that the building is not of the best construction but as it is not now feasible to make any radical alterations, I only desire on behalf of the State Board of Health to make two or three suggestions.*
>
> *There is a great lack of bathing accommodations. It is now recognized that the bathtub is a part of the necessary aids to the proper care of prisoners, both as to health and discipline. We must also object to the absence of any form of bedstead. It is the only jail in the State without them. Floor beds on damp floors are always objectionable. Beds so placed are never cleaned. We know of no jail authorities who would approve of such a plan as you now have.*
>
> *The pails now used for slop, etc., are not suitable for a jail. Metal pails of some kind are far better and cheaper in the end.*
>
> *While some structural alteration and extension is desirable, we only call your attention to those most needed and inexpensive improvements.*
>
> *Yours, most obediently,*
> *E.M. Hunt*[63]

It should be added that the placement of the keeper's children into cells was a matter of convenience for a growing family and not a nineteenth-century method of "time out."

7
Murder Most Foul

It came like magic in a pint bottle; it was not ecstasy but it was comfort.
—*Charles Dickens,* Little Dorrit

Unquestionably, other than Joel Clough, the Burlington County prisoner most reported on and talked about has been Wesley Warner. From a review of the newspaper reports and other information, it is not clear just why Warner has garnered so much attention over the years. His crime was horrible, to be sure, but no more so than those of Philip Lynch or Louis Lively. His life story was not so unusual for the times as to be remarkable, yet it was titillating. And, as we know, titillating sells newspapers.[64]

MISTRESSES, MAYHEM AND MURDER

In the case of Warner, this book would do more by doing less and simply presenting the newspaper reports as they appeared. On January 4, 1893, the *New Jersey Mirror* printed the following story:

> *The murder trial is still the absorbing topic of the day and the attendance would be greatly augmented if Judge Garrison would allow the people to use the standing room. Joseph Peak, father of the murdered girl was the first witness. He said Lizzie and the*

Stories from the Stones

Above, left: Wesley Warner—dapper, appealing and most definitely unstable. From a pamphlet published for public consumption shortly after the hanging. *Prison Museum Association.*

Above, right: Lizzie Peak—young, alluring and reckless. Her machinations in liaison with prominent people in Burlington City caused a major scandal in that town in the year before her murder. From a pamphlet published for public consumption shortly after Warner's hanging. *Prison Museum Association.*

prisoner first became acquainted while they lived in Burlington. He couldn't say who went with Lizzie when she went to Brooklyn to live; "she wrote home occasionally and my wife answered the letters; she came home twice during her stay in Brooklyn and was accompanied by Warner who roomed with her; when they went back they took my youngest daughter, Julia; they came back again in September, just a week before the Mount Holly fair; Warner drank a little at times; I went to the fair and one day saw Warner in a fight with some one; he was pretty drunk at that time; I was aware of the fact that Warner was not married to Lizzie while they were going together and sleeping in the same bed; I also knew that Warner was a married man at the time, having deserted his wife and four children."

The Burlington County Prison

As we read the witness statements from the trial, it is easy to see how family has always been the determining factor in individual behavior and morals. It is also easy to see how "upper class" people, who had better opportunity to hide liaisons, looked down on the "lower class" for flaunting theirs. While Wesley whiled away time in prison, his wife and children were left to fend for themselves, relying on the generosity of relatives. Amanda and Katie Peak, on the other hand, simply continued their *joie de vivre* lifestyles. The *Mirror* article continued:

> *Amanda Peak, a sister of Lizzie Peak, was next sworn. She said: "I first knew of Lizzie's intimacy with Warner when we lived in Burlington: when they moved to Brooklyn I went with them; Clarence Warner went with us; he is my husband; we were married in Burlington; we had two rooms in the same boarding house at Brooklyn as Wesley and Lizzie but came back home a week before the fair; that last night we went to the fair; the next night we went to the opera house; after the entertainment Lizzie, Katie and myself started home, accompanied by Harry Matlack, Thomas Shinn and Chester Stroud; Lizzie and Matlack walked ahead, Katie and Stroud next, followed by Tom Shinn and myself; when we turned into the South Pemberton road, we were compelled to walk single as the path is very narrow; we had not gone far before I saw a man get up from behind a bush; he arose from the ground very slowly, and I saw he had a knife in his hand...I saw him rush at Lizzie and saw him strike the fatal blow with the knife.*
>
> *At the bicycle railroad, Lizzie, her sisters and their escorts were having a good time riding the bicycles and "cutting up." They remained at the railroad for thirty to forty-five minutes. Shortly before midnight they all started to walk out Pine Street toward the girls' home. As they crossed the railroad train tracks on Pine street they began to laugh and sing. They joked with Joseph F. Bryan, who was walking in their direction.*
>
> *Katie Peak, another of Lizzie's sisters was next sworn. Her testimony was in all important particulars the same as that of Amanda.*
>
> *Charles Durand, living on Water street, Mt. Holly, was the next witness. He said: "I know Wesley Warner very well; became acquainted with him in Brooklyn; met him on the first day of the Mount Holly Fair last September, and he asked me to get him a*

Stories from the Stones

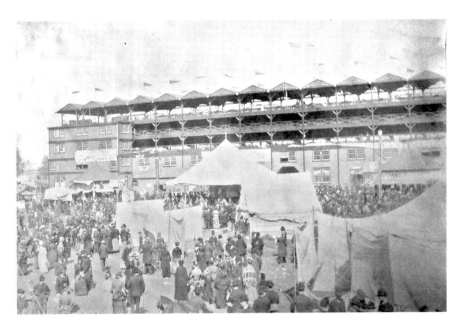

The Burlington County Fair; with horse racing, concerts, beer, food and the usual sideshow entertainment, this was the place to be in 1893. Wesley confronted Lizzie at the fair the day before her murder, and she spurned him. *Mount Holly Historical Society.*

job in the shoe factory; did not see him the next day; the next day, Wednesday, I met him at the corner of Main and Water streets and told him I could not get him a job; he had not been drinking; I did not see him on Thursday; on Friday morning I met him at the same place; he said he had a fight with four or five fellows on the Fair grounds the day before; he said he got into the fight because a woman had played him dirty, and he was going to kill her, and he would get square with the fellows who had hammered him; he was drunk."

Prosecutor Budd made the closing argument. He said there was nothing to show that Warner was a rum-crazed fiend when he killed Lizzie Peak. He had seen her on the Fair grounds in company with other men and his jealousy was aroused. Warner then began to threaten her. On Friday morning he said, "I'm going to kill her, she's played me dirt." The same day he told her sister Katie, "I've got revenge in her and I'll have revenge out of her," adding, "And I'll never set my foot in her g--d d--d door again."

THE BURLINGTON COUNTY PRISON

The Arcade Hotel, at the corner of Main (now High) and Mill Streets, where Lizzie spurned Wesley again on the night of her murder. From here, she went to the Opera House with her sisters. *Mount Holly Historical Society.*

> *Lizzie had told him she wanted nothing more to do with him and hence he was very angry. At night he came over to Mount Holly in a carriage with his mother* [apparently the day after the fair closed]; *got out at the corner of Main and Water streets and walked to the Arcade hotel where he met Lizzie. He asked permission to speak to her but she refused. He walked to Van Sciver's hotel when he met her again. Meeting Mr. and Mrs. Peak on Pine Street, Wesley went home with them.*

The editors of the *Mirror* obviously took delight in parading the circumstances of the victim's family and her past before the public. In July 1893, the paper reported:

> *Mount Holly is generally good for at least one lively episode per week and more particularly is this so during the summer solstice. The last one on record had a member of the now celebrated Peak family as the central figure. Within a few years this family has figured in more sensations than any other family in the State.*

Stories from the Stones

In 1890, Warner met Lizzie, who was then living in what was euphemistically referred to as a *boarding home* in Burlington owned by a man named Otho Bunting. Lizzie became attached to Warner and weaned him away from his family. The *Mirror* continued:

> *Lizzie, too had led a gay life and previous to her alliance with Warner lived in a commodious and comfortable establishment in Burlington at the expense of a prominent citizen of that city [Otho Bunting].*
>
> *The Peak and Warner families are a strange combination, and all concerned have been the subject of much comment since the murder trial began. Wesley is on trial for the murder of Lizzie Peak, whom he lived with for nearly two years but was never married to her. The wife whom he abandoned sits in Court every day with Warner's mother, sisters and brothers. Clarence Warner, the prisoner's brother, is the husband of Amanda Peak, one of Lizzie's sisters. They were married a couple of years ago but have not lived together for some time and Amanda has resumed her maiden name. The parents of both Lizzie and Warner were aware that they were living together illicitly, and instead of offering any objection seemed rather to encourage the misalliance.*
>
> *"Mrs." Laura Dunlap, of Burlington, a witness in Warner's behalf, proved to be a girl apparently about 15 years old. Her husband, also a witness, appeared to be but a year or two her senior.*
>
> *The following society item from the* Burlington Enterprise *may interest some who are reading the evidence in the murder trial: "Mr. and Mrs. Otho Bunting are spending the holidays in Chicago, combining business with pleasure."*

The family's reputation had been secured earlier, when Barclay Peak, Lizzie's brother, shot and killed his sweetheart, Katie Anderson. The site of this murder was less than a mile from where Warner killed Lizzie. Barclay showed little remorse and claimed it was self-defense:

> *Barclay Peak's trial upon the charge of murder proved to be a celebrated one, deep interest being taken in the proceedings in this and foreign countries. The medical experts were men of much greater note than those who figured in the Lizzie Borden and*

Warner's Gallows. It was traditional for the officials to pose with the contraption prior to the event. In this case, the officials are (left to right) Prosecutor Eck, P. Budd, Sheriff W.A. Townsend, prison physician W.P. Melcher, Coroner Enoch Dentworth and J. Kingdon, jury foreman (with dog). *Historic Prison Museum Association.*

Left: The cover of the proposal submitted by Mills to the County of Burlington for the design of its new prison (1808). *All insert images are courtesy Historic Burlington County Prison Museum (HBCPM) Archives.*

Below: Diagram of the proposed basement (first) floor of the prison. The keeper's quarters, private kitchen and inmates' kitchen are located centrally in this section, directly under the entrance stairs and office. Note that Mills intended the wings to house workshops, in keeping with the "modern" approach to incarceration.

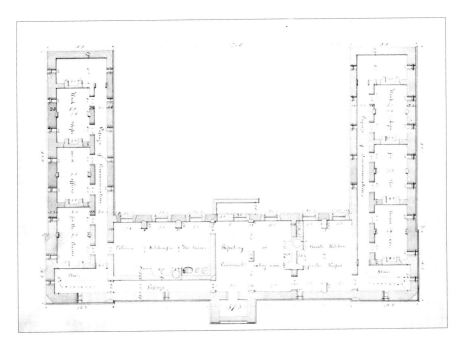

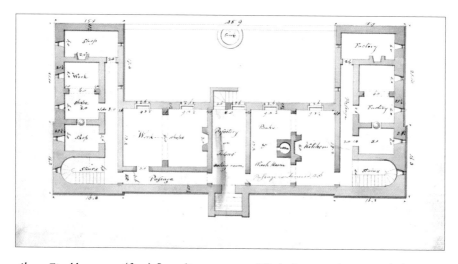

Above: Final basement (first) floor diagram, as modified after consultation with the county. Note that it is somewhat more modest in size than the initial design and the "office" and prisoner reception is located here. The warden and keeper generated records of the inmates and reports to the commissioners in this office before the county built the warden's house in 1887.

Below: Diagram of the proposed first floor of the prison showing the centrally positioned warden's office and reception area, as well as the common cells for debtors.

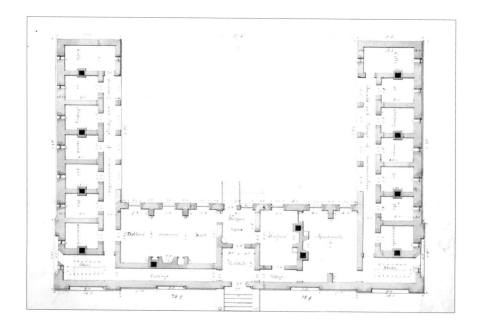

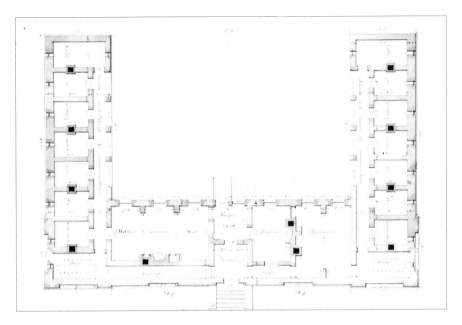

Above: Final first floor diagram, showing retention of debtor's common cells but inclusion of keeper's quarters for the live-in keeper and his family. Putting the keeper's quarters in this central location was intended to allow him to monitor prisoner activity after hours.

Below: Diagram of the proposed second floor, showing additional debtor's "apartments" and "sleeping rooms for the felons." Mills expected the inmates to be at work during the day. Also visible in this drawing are the numerous flues for the fireplaces in each cell—an innovation for the time.

Above: Final second floor diagram, showing little change from the initial design other than the shortening of the wings and elimination of the towers shown in the proposed drawings. The central cell (#3) became the "dungeon." Narratives always refer to it as cell #5, though no one can recall why.

Below: Roof truss diagram. The open sections on each end are the towers Mills intended in the original design but which were never built.

Above: Roof of the prison, as intended.

Below: Side elevation as proposed. The final construction was a bit different. It has been said that contractors of the period generally took architectural drawings as "suggestions," not as directives.

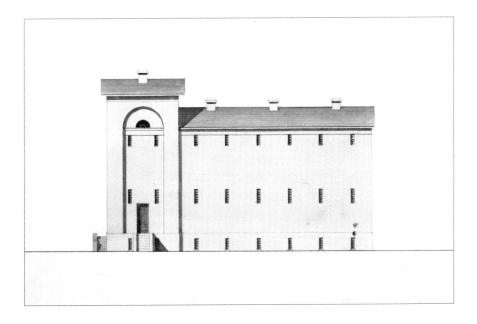

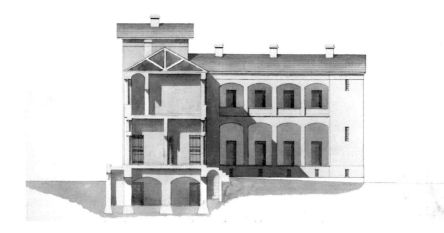

Above: Cutaway of the proposed side elevation showing stairwells, interior doors, etc. Mills specified materials and construction of these elements in his accompanying narrative.

Below: Final front elevation, as constructed and as the prison appears today. Addition of the warden's house and passageway extended the facility to the Grant Street intersection with High Street.

This page and next: Mills's 1808 proposal narrative. In it he outlines the philosophy and purpose behind his somewhat radical design and explains the rationale for heat, individual cells, separate debtor's quarters and space for work and employment training.

___Fifth. That the apartments of the debtors are more spacious admitting of the accommodation of several in one room and affords of superior privileges to those for the better

___Sixth. That a complete distinction or separation is made between the debtors and common felons

___Seventh. That the situation of the keepers apartments gives him an opportunity of inspecting the most material parts of the building.

___Eighth. That the passage of communication being general, one watch may suffice to guard the whole building. And

___Ninth. That there is a free circulation of air thro' all the apartments —

On the top of the building is a Belfry for the reception of a bell not only to serve as a time regulator to the prison but also as an alarm bell in cases of insurrection of the prisoners. Fire &c.

Thirdly. On the Internal order or physical and moral Government of the Prison. That means should be provided to enable the prisoners to maintain themselves by labor, even tho' a stipulated sum is provided by law to this effect, is a principle that needs no comment to prove the propriety of, and the rules of the prison should compel them to work, if they voluntarily were not inclined to it. There should be no discrimination of persons. Industry should be taught from experience (as it really is) to be one of the first Virtues. It is a melancholy sight in surveying most of not all of our debtors Goals, to behold so many persons compelled as it were to spend their time in idleness, may not only this but to be exposed to the scenes and temptations of vice in a variety of shapes. For as it will be admitted some several unfortunate men may be here confined is on the contrary there will be more of no principle or virtuous habits. And shall we be so inhumane as may say inhuman as to increase his misfortune by exposing him to the vile contact and converse of such!? No — if we cannot better his situation let us not make him use, or teach him vices which are the ruin of humanity. Show compassion there that would willingly labor to gain a pittance to support themselves or their families. It is cruel to deny them the opportunity. Let means be instituted to enable them to carry this virtuous resolution into effect, and let the fellow the disgrace of his fellow creatures be compelled to teach himself and to act a habit of these Virtues the neglect of which has brought him to his present wretched state. The miseries of a prison are great enough without adding to them. It is sufficient for an industrious unfortunate man to be confined there by a merciless creditor without depriving him of his virtuous habits and thus entail [illegible] more actual misery and distress upon him and his helpless families. Since as are our morals, we would certainly on the principles

The prisoners should take it in turns every morning to clean out every room, to air the doors & windows and air their bedding.

Sixthly. Dungeons.
It is customary to place the Dungeons or solitary cells under ground, if the object in confining the wretched criminal here is to destroy his health & make him miserable a more proper situation could not be chosen to effect it.
That it is an unsafe place Experience has fully proved, and the justly celebrated Howard in noticing this observes "I have found that escapes have been most commonly effected in undermining cells and Dungeons". Solitary prisoners have the best opportunity of accomplishing their purpose in their secret situations which the confinement is also calculated to create cunning. The most conspicuous and elevated situation should therefore be chosen for these solitary cells and very justly as here there is no probability of laboring much in secret or without occasional noise of discovery as they be surrounded with bars & serving & proof that the keeper [illegible] comes nigh to visit them daily. Upon these suggestions I have placed the dungeons in the most elevated part of the outer angles of the building. The walls are proposed to be lined with Oak plank and filled with scupper nails which render the difficulty of escape greater than thro' a five foot wall.

The Utility of an Infirmary in a prison cannot need be noticed
If in the Debtors prison a wash house should be offered it would be proper to appropriate three or four of the upper floors of the west wing for this apartment with two or three Ventilators

Encouragement should be given to the religious visits of Gospel Ministers the Debtors common hall may be appropriated for the meeting of the prisoners to receive their instructions —

I shall not enlarge further but come to a conclusion after soliciting your indulgence for having intruded my sentiments so far. Trusting that they will not be considered uninteresting I subscribe myself with sentiments of respect

Gentlemen

Your most Ob[edient] and humble [Servant]

Robert Mills Arch[itect]

[illegible signature]
Burlington 4 June 1808

Carlyle Harris cases. The court convicted Peak sentenced him to hang. He secured a new trial, however, and finally admitting that he shot the girl in self-defense, was sentenced to twenty years in State prison which he is now serving.

Even after his sentencing, Wesley Warner also managed to stay the execution through a series of appeals. During this time, the Peaks continued to play into the hands of the press and those inquiring minds that wanted to be "in the know." On May 17, 1893, the *Mirror* reported:

Before Justice Clevenger, on Saturday, Geo. Asay, of Burlington, and Katie Peak, sister of Lizzie Peak, who was murdered by Wesley Warner, were united in the holy bonds of matrimony.

On May 24, the paper noted:

George W. Asay, who recently married Katie Peak, says he thinks the newspapers are treating him very mean in coupling him and his wife with Wesley Warner and Barclay Peak, as neither he nor his wife are responsible for what they done.

One of the eyewitnesses to Warner's awful crime was Amanda Peak, sister of the dead girl, and she proved a most valuable witness for the prosecution. It is strange to relate, however, that another witness on the stand divulged that some time before, Amanda had been married to Albertus Warner, brother of Wesley, her sister's murderer. This revelation appears to have brought Amanda's married status back into the public eye.

On July 19, 1893, the *Mirror* printed the following:

Mrs. Albertus Warner, more familiarly known as Amanda Peak, was severely beaten with a blackjack by Lizzie Durand, wife of Charles "Lively" Durand, near the Pine Street railroad crossing on Tuesday night. Lizzie has not been living with her husband for some time, but at the same time she objected to his keeping company with Amanda Peak, and having seen them together at different times became extremely jealous. She informed Amanda that she must keep away from her husband, but the request was unheeded, and Charles claimed the right to walk upon the street with her in social intercourse, Amanda being an old friend, they

Admit Geo F Harbert Esq NJ

To Witness

The Execution of Wesley Warner,

At the County Jail, Mount Holly, N. J.,

On Thursday Morning, September 6, 1894, at 10 O'clock.

W. A. Townsend, Sheriff.

Not Transferable.

A ticket to the Warner hanging issued to a witness, court official or county employee. *Historic Prison Museum Association.*

having been employed in the same shoe factory in Brooklyn long before Wesley Warner killed her sister.

On Tuesday Lizzie [Durand] was in Mount Holly and in the evening went out Pine Street where she waited for Amanda, who came along on her way home later in the evening. Lizzie stepped out before her armed with a blackjack and a knife and threatened to kill her if she didn't keep away from her husband. "You've got one sister in the grave, and I'll put you there," she exclaimed, as she struck Amanda a blow in the face that knocked her down.

In the many years that have passed since then, three events—the Great Mount Holly Fair, the opening of the bicycle railroad and the murder of Lizzie Peak—have in some tales merged into one story. Lizzie Peak, the legend goes, was murdered while she was riding home from the Great Mount Holly Fair on the bicycle railroad. This is far from the truth.[65] The story is one that shows six young people leaving the local opera house and wandering through town, having a good time. Lizzie was probably murdered somewhere closer to Shreve Street, which parallels South Pemberton Road. Shreve Street becomes Railroad Avenue when it hits Eastampton Township a few hundred feet

farther along. The murder has been the talk of the town ever since; some get the details right, and some never will.

Wesley finally paid for his dalliance and uncontrollable jealousy. His wife and children paid as well, as they were thereafter viewed as the relations of a philanderer and murderer. Society was not kind to folks when it found family members to be wanting of proper behavior. Society viewed "bad" relations and poor family values as contagious and reflecting on all the members of the family (right or wrong). For the most part, families applied the apparent social implications of poor behavior (at various levels) in controlling the behavior of children. To shame the family name was worse than committing murder. Something might be said for that in today's environment.

8

Ragtime and Hard Time: 1900 to 1930

There isn't any such thing as a general crime wave.
—Ellis Parker

Detecting

During the Civil War, Alan Pinkerton formed a detective agency with the purpose of ferreting out criminals, Confederate sympathizers and bandits. The federal government formed the Treasury Department's Secret Service in the 1860s to guard against counterfeit currency, as well as to ensure revenue collection (hence the term "revenuers" used by the distillers of illegal whiskey). In 1902, the Secret Service assumed the role of protecting the president and became the nucleus of the current Federal Bureau of Investigation (FBI).[66]

Scientific method was all the rage at the time, no less so for criminology. Methods of detection continued beyond simple, broad-based physical descriptions (as seen in the runaway advertisements) to new scientific processes such as photography and Bertillonage. The fascination with a scientific approach culminated, for the period, in the fictitious detective Sherlock Holmes, created by Sir Arthur Conan-Doyle:

> *Juan Vucetich, an Argentine chief police officer, created the first method of recording the fingerprints of individuals on file, associating these fingerprints to the anthropometric system of Alphonse*

Bertillonage: the process of identifying a criminal from exacting measurements of his torso and features. This led to the application of fingerprints and mug shots for identification. Now we use DNA. *From Nickell and Fischer, 1999.*

> *Bertillon, who had created, in 1879, a system to identify individuals by anthropometric photographs and associated quantitative descriptions. A year later, in 1892, after studying Galton's pattern types, Vucetich set up the world's first fingerprint bureau.*[67]

These improvements in detection continue today, as DNA testing and retinal identification have become common methods of identifying culprits and securing convictions. The law officer of the latter part of the nineteenth century still relied almost exclusively on informants and a familiarity with the territory and population. However, as waves of immigrants arrived and populations began to move west and south, it became more difficult to base detection on knowledge of the community alone. Larger cities (New York, Chicago) had police forces, and these began to apply the new technological innovations:

> *Working in the Calcutta Anthropometric Bureau, before it became the Fingerprint Bureau, were Azizul Haque and Hem Chandra*

> Bose. Haque and Bose were Indian fingerprint experts credited with the primary development of a fingerprint classification system eventually named after their supervisor, Sir Edward Richard Henry.
> The Henry Classification System, co-devised by Haque and Bose, was accepted in England and Wales when the first United Kingdom Fingerprint Bureau was founded in Scotland Yard, the Metropolitan Police headquarters, London, in 1901. Sir Edward Richard Henry subsequently achieved improvements in dactyloscopy. Alphonse Bertillon continued to devise improvements in the system as well.
> In the United States, Dr. Henry P. DeForrest used fingerprinting in the New York Civil Service in 1902, and by 1906, New York City Police Department Deputy Commissioner Joseph A. Faurot, an expert in the Bertillon system and a finger print advocate at Police Headquarters, introduced the fingerprinting of criminals to the United States.[68]

One of the detectives coming of age in this period was Mount Holly's own Ellis Parker. Parker joined a force that consisted of an elected sheriff, appointed deputies, appointed local constables and local justices of the peace who conducted initial hearings and ruled on minor cases. By 1890, many cities and some towns had professional police forces with various degrees of effectiveness. Burlington County remained dependent on a variety of local officials and constables but drew considerably (as it always had) from developments and connections in Philadelphia.

Ellis Parker shined during the early part of the twentieth century. As the most prominent (and, for some time, only) detective during the period, he amassed a reputation as singular as Sherlock Holmes. This reputation was enhanced by a booklet called *The Cunning Mulatto and Other Cases of Ellis Parker, American Detective*, prepared by Fletcher Pratt from interviews with Parker. Of course, the stories are from Parker's perspective alone. A recent biography by John Reisinger[69] provides details into the persistence and ingenuity of this county detective and is worth the read.

As in previous decades, many crimes committed in Burlington County while Parker was detective were minor in nature. Gangs tended to prey on one another rather than the public. As Parker would say, "There isn't any such thing as a general crime wave."[70]

> *There is always some crime going on, because people always bring up their children in the same way, more or less. That's the way*

Left: An early photo of Ellis Parker. This image probably represents Parker about the time of the Rufus Johnson case. *Prison Museum Association.*

Below: The prison, from a 1906 postcard. *Mount Holly Historical Society.*

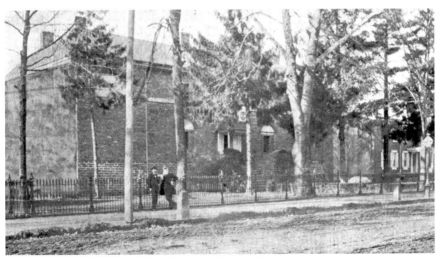

> *to prevent crimes, right in the home before it starts. You can say, though, that crimes do run in waves in one sense. There will be an outbreak of robberies, for instance and for a couple of months we'll get nothing but robberies. Then maybe it will be suicides or bank hold-ups, one right after another.*[71]

The rampant and random violence found today was not common. For the most part, those retained in the Burlington County Prison continued to be associated with public drunkenness, assaults or fights and theft or robbery. The conditions varied according to the number of people detained. The current Burlington County Jail, just down the street from the old facility, is nearly always full. The old jail's population varied from two or three inmates in 1881, to seven in the 1920s, to a then record sixty-six in June 1876, to thirty-five in 1886.[72]

Rufus Johnson and George Small

In his interviews, Ellis Parker noted to Fletcher Pratt that during the "old days" (twenty years previous) cases were solved pretty well and about as fast as during the modern era, with radio cars and fingerprint machines.[73] One case was that of the murder of Florence Allison.[74]

On February 7, 1906, the *Mount Holly Mirror* reported:

> *Rufus Johnson, the self-confessed murderer of Miss Florence W. Allinson, has been indicted and arraigned to plead and his trial has been set down for to-morrow before Judge Hendrickson and a jury. This special session attracted a great crowd of curious people to the courthouse and the street in front of the county property, but it was an orderly crowd and nothing savoring of a demonstration occurred when the Negro was taken from the jail to the court room to plead.*

Florence lived in Moorestown with her four-year-old niece, Bessie. She was a governess employed at an orphanage run by Margaret Strawbridge, a Philadelphia heiress. An oilman, delivering lamp oil, discovered her body stretched out on the floor of the barn at the rear of the house. From the position, and the condition of the dead woman, Parker concluded that she

had been beaten and that two persons had done the crime. The little niece was hiding in an upstairs bedroom closet.

Ellis Parker recalled:

> *I doubted whether she had been an eyewitness of either the assault or the murder, for the men callous and cruel enough to have killed Miss Allison would probably have killed her too, in that case.*

Parker, having raised eight children, realized that nothing would come of barraging the girl with questions. She was too frightened. He decided that he would take her for a walk, told the investigating doctor this and the two left the house:

> *On the way down the street, I didn't say a word till we came to a candy store. I noticed her eyes sort of turn toward it. I asked her if she liked gumdrops, and she nodded. I went in, got a big bag of gumdrops, and gave one to her. We continued down the street, and I was leading her toward the Moorestown police station, which was as good a place as any to leave her for the moment.*

Bessie stopped and pulled at Parker until he listened. She then simply blurted out, "The black man took Aunt Florence's clock." Parker went to Philadelphia and talked to Mrs. Strawbridge.

The questioning of Mrs. Strawbridge led to the discovery that the clock mentioned by Bessie was, in fact, Florence's gold pocket watch. Her brother had purchased it for her while they were both still living in England. So the case of the murdered governess took another strange turn as the British Embassy became involved. British police in Liverpool were tasked with finding the dealer who sold the watch so as to get a description.

Several clues indicated that the murderers were transients—tramps in search of quick cash. A quick pawn deal without proper identification of the watch to alert dealers would end the case. The only person who could actually identify the criminals was a four-year-old with a good imagination—not the best prognosis for solving a case. An interesting process evolved, one that would be frowned on today, no doubt, but is essentially similar to a lineup:

> *First thing in the morning, I want you to get all the Negroes you can find into this office. Men only. You can tell them we don't want to arrest them for anything. We just want them to help us*

out. Upstairs I took Bessie on my knee and had the stenographer come in with her notebook. I told my assistant to bring in one of the men; any one. I gave Bessie a gumdrop and asked her if the man looked like the one who took the clock.

Each time, as Bessie shook her head no, Parker asked what was different. In many ways, this is what a police sketch artist does today. Eventually, Parker got a reasonable description, by which officers could at least discount potential suspects. The team now was of the belief that the two murderers were tramps, working their way south and paying for it by robbing isolated homes. Thus, the authorities were able to set their sights on the rails and on larger cities as the likely destination of the stolen watch.

It is hard to believe today, with GPS and satellite communication, that the Mount Holly team was able to solve this case within forty-eight hours—in 1906. With help from police in Liverpool, they tracked the identification number of the watch and had a good description. Using cables, telephones and the network of police in several larger cities, they were able to get word to pawnshops to look for a man of a particular build pawning a watch of that description and serial number.

Baltimore police called within the hour stating that they had a man of that description pawning the Allison watch. His name was Rufus Johnson. The papers at the time cited information that Johnson pawned the watch in Philadelphia, but the statements varied according to the testimony released by the police. The desperate speed by which newspapers released the stories seems to rival today's Cable News Network (CNN). The *Mount Holly Mirror* printed the following story:

> *Contrary to the information given out by some of the county officials that the extradition of Johnson would not take place until Wednesday night last, the Negro was brought up from Baltimore on Wednesday afternoon, arriving here shortly before 2.30 o'clock. Deputy Sheriff Fleetwood and Detective Parker had charge of the expedition. Both were in Baltimore on Tuesday afternoon prepared to deliver the requisition papers and remove the prisoner as soon as he was placed in their custody, but no attempt was made to leave the city until Wednesday morning. The trip from Baltimore to Philadelphia was made by train and the party arrived at Broad street station about one o'clock. There the two Mount Holly officers were met by an automobile in charge of Robert M. Snyder, of*

Moorestown, and a chauffeur named Ward. Johnson was rushed from the terminal to the White flyer and he was soon hidden from public gaze, being stowed in the tonneau and covered with blankets. A great crowd witnessed the arrival and departure of Johnson and before the automobile was started on its wild run to Mount Holly even the officers were not sure that they were not going to lose their prisoner. The excited people carried sticks and stones and many threats were heard.

There was a little stop in between, not noted in the papers. Parker took Johnson to the Allison house. While he sat in the kitchen with Rufus, Parker had Bessie brought in and asked her, "Is this the man who took Aunt Florence's clock?" Bessie stared and then broke into tears. Johnson confessed right there.[75]

The last mentioned were by far the most advantageously situated. Under the pre-arranged plan the automobile ran up Grant street to the Sheriff's residence. Inside officers were waiting to throw open the doors when Johnson was hustled from the machine and the whole proceeding was over quick as a flash—Through the Sheriff's house and the passageway that connects it with the upper tier of the jail Johnson was soon in the stronger stone building, and within three minutes he was locked in his cell. It is believed that not more than half a dozen persons saw the negro when he was taken from the automobile to the house. The whole affair was very carefully planned and those in whose charge Johnson had been placed have since been congratulated upon the success of the trip.

Rufus was tried, based on his confession. He gave up George Small as the second man and said they had talked about killing Bessie as well but thought it would be too much trouble. George, subjected to "sweating" by the detectives and pressure from his wife, succumbed and confessed that he had assaulted Florence Allison and strangled her with help from Johnson. Johnson gave a different story, indicating that he had assaulted Florence when she discovered him hiding out in her barn (apparently after robbing a house the prior evening). Who to believe?

It is interesting to note that George Small was married, yet Parker's image of him in retrospect was that of a tramp traveling south. Small lived in Moorestown and had hosted Johnson for a few days prior to the murder.

The Burlington County Prison

Small's wife was arrested as a material witness and put pressure on him to confess his role. George Small may well have been innocent, or Rufus Johnson may well have encouraged his vicious actions. Either way, according to the courts, they were both guilty. The *Mirror* reported:

> *When seen this morning lawyer Jacob C. Hendrickson expressed keen satisfaction at the turn affairs had taken. He said he had all along given credence to Johnson's second confession, which had been chiefly the result of his repeated admonitions to Rufus to make amends for his participation in the murder of Miss Allinson by giving a truthful account of the crime before he went to the gallows. Lawyer Hendrickson said that he believed it would be well to have the execution deferred until Small's fate was determined. Johnson has frequently expressed his desire to have the hanging take place on Friday next and has told his counsel that he did not wish him to take any steps looking to delay in carrying out the court's decree. Prosecutor Atkinson stated this morning after Small had made his legal confession and signed it at ten o'clock that he would go to Trenton to confer with Governor Stokes and others relative to the new situation and it will be for them to determine whether execution of Johnson will take place on Friday.*

According to the *Times* of Trenton on February 21, 1906, "Governor Stokes reprieved Rufus Johnson, convicted of murder in Mount Holly."[76]

The case shows some important elements of police practice for the period: the "sweating" of the accused to extract a confession, the breaking of the two by playing one against the other and the implication of the wife of one man to get him to confess. Parker's somewhat less abusive process nailed Johnson, though he recanted later and then confessed again, naming Small as the actual murderer. One might ask whether this would have been the outcome had DNA testing been in place at the time. According to the *New Jersey Mirror*:

> *Rufus Johnson, smiling and resigned to his fate, and George Small, with despair and fear written in every line of his face, were hanged at the county jail at 10.09 o'clock Saturday morning* [presumably a reference to March 24, 1906] *by Sheriff John J. Norcross, in expiation of the brutal murder of Miss Florence W. Allinson, at*

Moorestown, on January 18 last—a crime that aroused all New Jersey and the States adjoining. The speed that marked the execution of the law's mandate was surprising and Sheriff Norcross has the satisfaction, if there can be any, of having conducted probably the cleanest and swiftest hanging on record. Within two minutes from the time the condemned men were started from their cells in the upper tier of the county jail on the march that led them to death the trap had been sprung and they dropped into eternity. In effect death was instantaneous, being so pronounced by the physicians in attendance upon the bodies.

LOUIS LIVELY—SERIAL CHILD KILLER

Child murders and abductions are not a new phenomenon, as noted in earlier chapters. However, when Louis Lively came on the scene, they were still something most folks did not talk about—at least not openly. Eleven-year-old Matilda Russo was reported missing from her family home in Moorestown. After the usual check at school and neighbors' houses, detectives determined that she was gone and began searching.

"I couldn't see anything but a degenerate case in it," Parker told Pratt. There were no leads, and the only clues would have to be deduced from interviews of all people on the route from home to school. The family was too poor for a ransom kidnapping. Parker and his team spent the weekend asking questions of everyone in the area. One of those questioned was a man living only a few hundred yards from the Russo house. His name was Louis Lively.

When Parker returned to question neighbors again that Monday, a woman answered Lively's door and said Louis was away. Checking the house, Parker determined that "away" meant "scrammed."

I noticed that two things were missing, suitcases and men's clothes. I was pretty sure Lively had more clothes than those he had on him when I saw him the last time, so I knew right away that Lively had gone with no intention of coming back.[77]

Investigating the house, Parker ended up in the cellar. Noticing disturbed earth under a pile of ashes, he washed away the dirt and found a shallow depression:

The Burlington County Prison

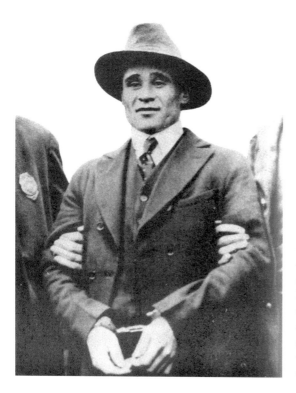

Louis Lively, the child killer. Louis, the "Cunning Mulatto," was caught after a long international chase and convicted of heinous crimes, resulting in execution at the state prison. He was smug to the end. *In Fletcher,* The Cunning Mulatto.

The earth was packed so hard it collected in little puddles—in all places except in the corner, where it sank right in. About a foot down we found Matilda Russo. Her throat had been cut and she had been disemboweled—a typical degenerate's crime. Instead of tipping us off by running away, he had made us give him a warning, and now he had a whole day's start on us.[78]

Lively's wife, the woman who answered the door, was put into the Burlington County Prison as an accessory pending investigation. Lively's record in Philadelphia was extensive, mostly assault and stabbings. Checking the records in the various counties, Parker's deputy discovered a similar crime involving a young girl. Jeanette Madison had been killed in exactly the same way a year earlier in Morris County. Lively had lived in Morris County before coming to Moorestown. Tracking Louis would take a long time.

Watching Louis's sister, Parker discovered that she had been receiving a newspaper from Charles City, Virginia. Louis was a brush maker by trade and had an enormous appetite for spending. He would need to work to feed his

sweet tooth and habits. The bulk of brush companies were in New England. Virginia did not make sense, so Parker looked elsewhere.

The circulars went out to the Boston police, and a manufacturer responded right away, stating it had turned down a man meeting Lively's description because business was slow. Boston police tracked the man's address, but he was gone. About the same time, Parker noticed that copies of the Boston papers were arriving at the sister's house—another red herring.

Parker and the Massachusetts police tracked Lively to a fishing boat off the coast of Gloucester. When it returned to port, they were waiting, but Lively was gone. He had jumped ship in Halifax, Nova Scotia. The trail was now international. The Canadian police had no information on him, and the trail went cold. After receiving threatening letters from Lively posted in *Trois Riviers* (Quebec and Windsor, Ontario), Parker knew that Lively was coming back into the United States through Detroit. The letters helped Parker trace Lively's informant, who was keeping the fugitive abreast of the actions of the police. It was his sister.

Lively's wife was released from the prison, to let him think things were slowing down. Three detectives watched his sister, but she didn't do anything suspicious. Parker recalled:

> *I wasn't satisfied. I had them make out daily reports of what she did and after ten days of watching, in going over those reports, I noticed something that seemed to need explaining. She was getting grapes by parcel post about three times a week. It was October and there were any number of grapes in the local stores. One day, I managed to get one of those baskets.*[79]

Parker found a note, written on brown paper, wrapped carefully around the stem of one bunch of grapes. The note simply stated, "This job is done. Will see you soon." Parker based his next step in this game on Lively's penchant for large meals and sweet deserts, checking with all the area restaurants and hotels. They were asked to look out for a Negro customer with a large appetite, topping off the meal with lots of pudding.

In October, they got a call from a lunch wagon in Vineland, about forty miles south of Mount Holly. Parker sent two policemen to investigate, and they encountered a man who behaved suspiciously when they approached. He was walking along the road and began to run when he recognized them as police. The man, a mulatto like Lively, turned and fired on the officers, seriously wounding one of them. The second officer grabbed a

shotgun from a nearby farmhouse and pursued the man into the woods. It was Lively.

When Lively ran out of ammunition, the officer jumped him and knocked him out with the butt of the shotgun. Louis Lively was executed the following January. His family refused to bury him in the family plot.

While Louis Lively's wife was in the prison, she may have been temporarily quartered with another desperate inmate, Ivy Giberson.

THE MURDER OF WILLIAM GIBERSON

Ivy Giberson was extremely religious, except when it came to obeying the commandment prohibiting murder. *In Fletcher,* The Cunning Mulatto.

Throughout the prison's history, it held female inmates, in greater or lesser numbers, but not usually for murder. Eliza Freeman was the first woman held for murder in the new prison. Ivy Giberson was not the last, but she is an excellent example of the lengths to which someone will go when piqued. Bringing to mind Keturah Anne Brooks, Mrs. Giberson determined to rid herself of an unwelcome spouse.

Ellis Parker was the detective for Burlington County. The case of Ivy Giberson took place in Ocean County but had Burlington County connections. Several years earlier, there had been a rash of arson fires and horse thefts covering Monmouth, Burlington and Ocean Counties. In response, officials in all three had formed what Parker referred to as the Mount Holly Pursuit Society. The resulting collaboration was successful in ending the string of arson fires and the deaths of hundreds of horses. From that time on, it seems, the authorities in each county collaborated regularly, and this collaboration was in evidence on the Giberson case.

Parker interrogated Ivy in Toms River, the murder having occurred in Lakehurst. His knack for getting people to "hang themselves" during his

Ellis Parker and his team on the steps of the prison, circa 1920. *Prison Museum Association.*

interviews and investigations brought him into the case. His interrogation resulted in a conviction of Ivy for the murder of her husband.

Ivy was a well-known social worker in the area and was known to be involved in church functions and beneficial activities. Though she was a teetotaler, her husband, William, was a bootlegger. Perhaps the mix of religion and alcohol was simply too volatile.

9

Depression and Decline

We have whisky, wine, women, song and slot machines. I won't deny it and I won't apologize for it. If the majority of the people didn't want them they wouldn't be profitable and they wouldn't exist.
—*Enoch "Nucky" Johnson*

C rime fighting had changed. Fingerprints and mug shots were standard practice. The relatively new Federal Bureau of Investigation offered a central repository for criminals who had previously been able to cross county or state lines and vanish. This was a period of infamous gangsters and bandits. People like Bonnie and Clyde, Baby Face Nelson and others ran rampant through the Midwest and South. "Little Al" Capone was headline material. Crime was not only good for the news media, but it was almost fashionable.

At the same time as those popular gangsters of the Midwest were grabbing headlines, the underworld of Philadelphia and Camden continued to serve as a haven for thugs and ne'er-do-wells from throughout the region. Long connected through shipping and dock worker organizations, Camden, New Jersey, and Philadelphia, Pennsylvania, sit across the Delaware River from each other and offer easy opportunity for moving goods and people "across state lines" to avoid the law:

> *The Philadelphia, Pennsylvania faction of La Cosa Nostra has been one of the strongest families in the American Cosa Nostra since its start in 1911. Salvatore Sabella was sent to Philadelphia*

by the bosses of the Sicilian Mafia to organize the city's rackets. Sabella was the boss of the Philadelphia mob from 1911 until his death in 1927. He was succeeded by Joseph Bruno. Bruno was in power essentially from 1927 until 1946. There was a period during his rule when his power was challenged by John Avena. This was sometime between 1934 and 1936. Bruno retained his power, but died in 1946.[80]

Atlantic City, at the same time, was the scene of decadence and consumption unheard of in the average household. It was already a playground for the rich and famous by the end of the nineteenth century. By the time Prohibition hit, the city had become the source of much of the bootlegging and distribution of hooch in the region. Burlington County runs from near Trenton and Camden to the shore at Tuckerton and covers much of the remote Pine Barrens that have been a haven for smugglers since colonial times. It is not surprising, then, to find that the Burlington County Prison saw its share of mob figures.

Not the first or last, but among those most remembered was Eddie Adamski. Adamski was brought to the prison as an accused member of the After-Dinner Gang. This gang specialized in robberies committed when the family was out to dinner and that appeared to be very well planned—professional jobs. In the middle of the Depression, these heists pulled down hundreds of thousands of dollars for the thieves and those who "fenced" the goods. In his recollection of Adamski, Parker noted that the robberies started in 1932, about the time future members of the gang were released from prison in Philadelphia.

In his description of the affair to Fletcher Pratt, Ellis Parker points to several failures in the system of the time that resulted in Adamski escaping and then staying on the lam for a long period. In reality, Adamski was working with a three-man team robbing houses of wealthy persons in the South Jersey and Philadelphia areas. A murder in Palmyra, New Jersey, which seemed unrelated, ended up providing the evidence that broke the case of the robberies. According to the *Camden Courier-Post* of June 19, 1933:

> *Eddie Adamski, most notorious of local gangland's safecrackers, has escaped from Mt. Holly jail. He was in solitary confinement, allegedly under special guard and allowed no visitors other than his sister. He sawed away the bars of his cell early yesterday and fled hours before his disappearance was discovered.*[81]

Eddie Adamski Wanted Poster. Eddie was relatively important in the Philadelphia and South Jersey mob, at least according to Eddie. *Prison Museum Association.*

The *Mount Holly Mirror* reported:

> *Adamski is the lone survivor of a gang of 12 men, known to Philadelphia police as the "Seventh and Parrish streets mob." His delicate sandpapered fingertips have opened a thousand safes without the aid of knowing the combination, police said. He has been arrested scores of times and spent much of his 28 years in jail.*

Adamski ended up in the Burlington County Prison as a result of attempting to pawn a ring from one of the heists in a Newark hockshop. After grilling the suspect, Parker made the connection between Adamski and a pistol stolen in Illinois that had been used in the murder in Palmyra, New Jersey. Adamski paled when told about the possible connection, wailing that he "wasn't no murderer."

The *Mount Holly Mirror* continued:

> *At 7 a.m. yesterday, one of the two jail attaches went to Adamski's cell with his breakfast. His cell was empty. Three bars had been neatly sawed away from the lone window, leaving a space 13 by 7 inches, hardly enough for anyone to squeeze through. Authorities were puzzled how he got the saw. He filed through three bars, each an inch and three-quarters thick.*
>
> *Attached to one of the remaining bars was Adamski's bed clothing, knotted together and stretching to within a few feet of the ground, 20 feet below. While his fellow prisoners had been asleep—and the guards apparently busy elsewhere—Adamski had filed the bars, made his rope of bed clothing and fled. A saw horse placed against the wall of the yard at the sheriff's house, where Wimer has his offices and a deputy sheriff lives, showed where Adamski had made his final bid for freedom. The wall at this point is slightly lower than around the rest of the yard.*

Prison officials there said they were certain that nothing was concealed on his person when he was turned over to Burlington authorities. In Parker's memoirs, he states that he was informed by one of his detectives that

Newspaper illustration of Eddie's escape. *Prison Museum Association.*

Adamski "slugged his guard" to escape. The story says he cut the bars, but the hole was small. Perhaps he cut the bars, realized it was too small after stringing his homemade rope out and decided the better move was to just slug the guard.

According to the *Camden Courier Post*, "'I can't see,' Chief Parker said, 'how any man could get through such a small hole. But Adamski must have done so because he's sure enough gone.'"

The familiarity with Adamski and the various gangs in Philadelphia and South Jersey indicated that law enforcement was well aware of their activity and personnel. Philadelphia police trailed a man named Zeleski, believing him to be part of a drug operation. He was connected to the After-Dinner robberies in New Jersey through a cohort, who had in his possession a $100,000 bond taken in one of the robberies.

Tailing this Zeleski, who drove a car with New Jersey plates into North Philly, authorities rousted him and found more bonds. Threatening to lay the murder on him, they got him to squeal. From this came the tale of the owner of the car, a man named Solomon Lutz. Lutz lived in New York, so Parker sent two detectives to New York.

There, after trailing Lutz through the Upper East Side during two snowy weeks, they saw him talking to someone in a small stationery store. After a while, he left, and they checked on the guy Zeleski had been interested in. It was Eddie Adamski.[82] Adamski was returned to the Burlington County Prison and tried for the murder as well as the robberies.

Police work from departments in Burlington County, Philadelphia, and New York were involved in the case. Adamski was one of two men in the gang convicted of murdering the man in Palmyra, using the gun stolen in Illinois.

Separate Facilities

The warden segregated inmates by sex and crime throughout the prison's 154 years of operation. The limited number of female prisoners early in the nineteenth century probably led to the assignment of a few cells for this gender. Later, as the population rose, the left cellblock, first floor (above the ground), was reserved for females. The left stairwell was blocked off at the basement and second-floor levels to bar access by male inmates. Available records (prison register) indicate that girls as young as eight years old were incarcerated, at least for brief periods.

The situation seems to be in line with that found by Newman in the Philadelphia system of fifty years earlier. The words "and child" next to an occasional female name would seem to indicate that nursing mothers, or mothers with no family or child care available, were allowed to bring an infant or young child with them.

All the same, Stan Fayer notes a condition that was hardly limited to his period at the jail in the 1950s and '60s:[83]

> *One night when Ms. Spinner and I were working together, she mentioned that the girls in the women's section were bathing much less than usual, some of them seemed never to bathe at all, and she couldn't figure it out. After some time while doing a routine check of the cells we found the prisoners in the cells above the women's section on the second floor had somehow drilled a hole in the floor and were lying on the floor watching as the women put on a show below them. We never did find out how they drilled the hole, but if you look at the floor today you will probably see where the hole was filled with concrete.*

The security of the Burlington County Prison, ever suspect, was becoming an embarrassment. Adamski's escape, only one in a long series of escapades, showed the weaknesses in the original design as applied to an increasingly sophisticated inmate population. Regular decay and failure of infrastructure caused the prison to be labeled uninhabitable as early as 1920. Yet the county saw fit to retain the prison without major changes. The families of the wardens continued to have regular, occasionally unexpected, interactions with the inmates:

> *Charles Farner recalled that, as a boy, he experienced daily contact with the prisoners, including one who was found in the warden's house. Charlie, brother Bernie and sisters Marian and Susie, lived with their parents upstairs in the warden's house. The house was constructed in 1887. Their kitchen was downstairs in the warden's house addition, as was the warden's office. One day an inmate escaped from the lock up next door and sat in the kitchen of the warden's house waiting. He was discovered when Charlie's sister arrived home from a date. To get there he would have walked right past Charlie's bedroom window.*[84]

Ellis Parker and his wife in a carriage in front of the prison in 1933. Parker noted that his entry into detective work was the result of the theft of his horse and carriage in his early years. He continued to enjoy driving one. *Prison Museum Association.*

Apparently, life as a member of the warden's family meant regular, daily contact with the inmates. In one case, the inmate must have felt like part of the family. Joe Werner, a cook at the same time Charlie was living there, had an affinity for the prison. On the day his sentence was up, he told the warden he would be back that night. He proceeded to get drunk, arrested and brought back to the prison. The jail was his home.[85]

To some extent, the jail was Parker's home as well. He spent more than thirty years working cases in the county and was renowned for his style and technique. His downfall came when he bucked the commonly accepted outcome of the Lindbergh baby murder. Parker was convinced that Bruno Hauptman was not the killer and proceeded to make a solid case. However, as the case had already been settled to the satisfaction of the public, the powers that be determined that no new trial would take place. Parker, determined (and perhaps a bit headstrong), was disgraced by his actions in securing a witness and pressing the investigation.

10

Stranglers and Cooks

I asked a man in prison once how he happened to be there and he said he had stolen a pair of shoes. I told him if he had stolen a railroad, he would be a United States Senator.
—Mary Harris Jones

It is said that most career criminals learned their trade in prison. Considering the proximity to inmates of varying experience and maliciousness, this is easy to understand. Once inaugurated into the assembly of thieves, rapists and thugs, accepting an apprenticeship is easy; however, challenging the brotherhood is not easy and often not healthy. Still, with no place to put many of the lesser criminals—those with drunk, disorderly or vagrant listed after their register entries—proximity to more formidable felons was inevitable.

The greatest proportion of commitments was due to the usual offenses. Vagrancy declined as a category, replaced with assault, larceny, theft, shoplifting, carnal behavior (prostitution), carnal abuse (sexual assault), etc. The number of women sentenced increased during the twentieth century, including those committed for generally lewd behavior. Not many men were committed for the same offence, though police and the courts appear to have more closely scrutinized sexual assault than in the past (according to prison register entries).

THE BURLINGTON COUNTY PRISON

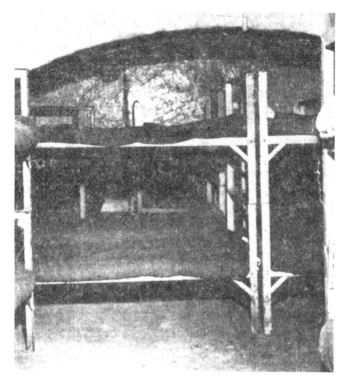

Giving new meaning to sharing rooms, this setting resembled the country inn rooms of the eighteenth century more than a modern prison. The crowding began as sentences grew longer (up to 364 days) and the county population increased. *Prison Museum Association.*

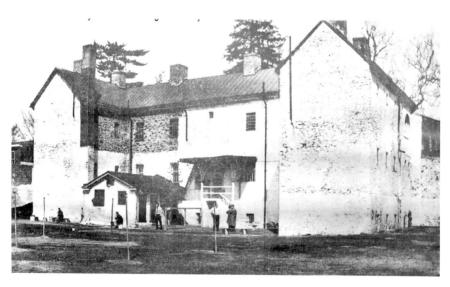

Prison yard, 1950s. Note the relatively informal fencing in place within the yard. *Mount Holly Historical Society.*

Stories from the Stones

Justice Failed? The Boston Strangler

Albert DeSalvo had just returned from serving in the military in Germany and was stationed at Fort Dix. This base served many of the soldiers returning from European duty in those days and was a training and reassignment center. It is now part of what is termed "Joint Base McGuire-Dix-Lakehurst."

From the time of its inception in 1917, the base was surrounded by the small towns of Wrightstown, New Egypt, Juliustown, Pemberton and Browns Mills. As with any military base throughout history, these towns have seen their share of entertainment for troops on leave. Today, they consist mainly of developments and have become a different kind of "bedroom community."

The story is that, one night, Albert went to a local bar in Wrightstown, where he met up with a woman who took him home with her. He then assaulted her daughter. A discussion the museum staff has had with people in the area at the time disputes this traditional account.

According to personal statements, the child was playing in her yard in Juliustown during the day. Juliustown abuts the training section of the base, which is unpopulated and thick with woods. DeSalvo grabbed her, dragged her out of her yard and raped her. DeSalvo was never convicted because he had clever lawyers who kept delaying the court proceedings. The child kept being taken out of school to attend court, and then there would be a delay. Finally, the parents decided to stop the mental anguish this was causing their child.

The official charge against him was "carnal abuse." He was brought into the prison in early January 1955. The county held him for two days and then released him back to military authorities because the child would not testify against him. Because there was no trial and no "crime," he completed his obligation to the army.

DeSalvo was discharged from the military and returned home to Massachusetts. There he worked in construction supporting his wife and daughter. It would seem that Albert had a number of "side jobs" as well. He continued the pursuit of his criminal behavior and was arrested several times for burglary and sexual assault in Boston. This continuance seems to indicate that the Juliustown incident was not his first assault, but there were no firm laws to register sex offenders or child molesters in those days.

Then, in the early 1960s, there came a rash of murders in Boston:

Between June 14, 1962 and January 4, 1964, thirteen single women in the Boston area were victims of either a single serial

> *killer or possibly several killers. At least eleven of these murders were popularly known as the victims of the Boston Strangler. While the police did not see all of these murders as the work of a single individual, the public did.*
>
> *Even though nobody has ever officially been on trial as the Boston Strangler, the public believed that Albert DeSalvo, who confessed in detail to each of the eleven "official" Strangler murders, as well as two others, was the murderer. However, at the time that DeSalvo confessed, most people who knew him personally did not believe him capable of the vicious crimes and today there is a persuasive case to be made that DeSalvo wasn't the killer after all.*[86]

DeSalvo confessed to attorney F. Lee Bailey, who cut a deal that sent him to prison without ever being tried for the murders. Thus, evidence was never presented or rebutted. For many, this leads to the belief that Albert was not the Strangler but someone seeking the reward and the notoriety. (Bailey went on to fame and fortune.)

> *According to Susan Kelly, who wrote a detailed book about the case, DeSalvo could easily have picked up details about the case from newspaper accounts, prison roommates, and the press releases of the coroner and others. Police speculated that George Nassar, a man in prison with DeSalvo, could have been one such source of information. Since DeSalvo appeared to be willing to confess in order to have the reward paid to his family and to become famous (he had nothing to lose), another inmate could easily have exploited this. It has been done in other cases.*[87]

So the issue remains: was Albert DeSalvo the Boston Strangler or simply a nasty criminal in search of fame? Either way, he was one of those subterranean culprits who practice their hobbies out of sight of the public and their families while maintaining an aura of repute and stability. Even if the county had been able to convict him of the assault in Wrightstown, based on his subsequent history, it is doubtful his path of self-destruction would have changed course. Based on the sentences handed down in the period for similar offenses, it is doubtful he would have served more than six months anyway.

Assorted items collected by the prison over the decades. *Author photo.*

COOKING AND "FIRST AID"

A docent told how, one day after a school group had completed its tour and he was locking up the prison, an older woman asked if she could come inside. When she did, she told him that when she was a little girl, her father had been the warden. In the kitchen area in the lower section (the ground level), it was warmer. In the winter, she would wait there for her father, and the cook would give her treats.

Once she asked what he was doing, and the cook said, "Baking a cake." "He cut off a piece and gave it to me. I asked my father what the nice man was in jail for and he replied, 'Oh, he's waiting trial for murder.'"

Former prison guard Stan Fayer recalled:

> *One night the court let out, and they sent the people that were sentenced to the jail to the prison. One by one they were strip-searched and given jail clothes. I seem to think I was working with Fred Schildkamp that night, and after we had searched most of the people coming in we came to an older fellow who was a regular.*

The walkway connected the warden's house (built 1887) with the main prison building. The gallows were in the yard below this. *Prison Museum Association.*

His name, I think, was Pat Horn. Pat only had one leg, but he had a hollow wooden leg. Thinking we wouldn't make him take the leg off, but we did, Pat had his "in Jailhouse first aid kit" with him. The kit consisted of a deck of cards, a handful of small change, a small penknife, several packs of cigarettes and a pint of cheap whiskey. He was so mad when we confiscated his treasure-trove, he called us every name he could think of and even some I think he invented at the time.

Pat was one of several old guys that would do something to get sentenced to jail for the winter. They would be put in the "subway" with the work crews and each day be taken to Buttonwood Hospital to work. The guard that would take them was an older fellow whose name eludes me right now, and [he] was older than they were. I'll probably think of it in the middle of the night, I do remember that he was the mayor of Beverly. If it got close to winter and the "boys" didn't show up, the residents of Buttonwood would

start asking where they were and if they were OK. Actually, they should have been residents, but they wanted their freedom in the good weather.

Officials used "the passageway" to get Rufus Johnson (and others over the years) safely into the stone prison when crowds waited out front. In the later years, the passageway was used to store extra clothing for prisoners and work clothes for the guys in the "subway."

11

Too Close for Comfort: 1960 to 1965

Hope is a dangerous thing. Hope can drive a man insane.
—Shawshank Redemption

The conditions of the prison that were mentioned as early as 1918 meant doubling and quadrupling in the cell spaces designed for one person. By 1960, prison reform meant longer sentencing and more reliance on removing people from the community rather than rehabilitating them.

The use of jail time to manage indigent and transient populations also increased, though deportation remained an option. Work as rehabilitation had long been replaced with hard labor as an end in itself. Being on "the county farm" meant long hours and weary bones but was still better than the archaic and debilitating chain gangs employed in the South and West. Conditions in most prisons around the United States (and elsewhere) were so bad that prison riots made the news almost every month.

Retired judge Victor Friedman was a young lawyer during this period. He recalled that in 1960, Burlington County was small and rural, with about 250,000 people in the whole place:

> *After the County closed the old prison, and up to about 1975 when the new court building and jail were completed, they kept the prisoners in the old National Guard armory. There were lawsuits all around the country about prison crowding and conditions. Reform was something everyone wanted to achieve but no one*

wanted to invest in. In Burlington County, the freeholders finally realized they needed a more secure setting than could be achieved by renovating the old prison.

Stan Fayer recalled, "I seem to remember the count to be between seventy-five and eighty-five prisoners. Which is very small compared to today, but there would only be three of us staffing the jail; two men and one woman."

Judge Friedman noted that the courts were more colorful then than they are now, with jokes and genial arguments, table talk and tall tales filling the trials. Trials were quick, and there were terms for the courts. Trials stopped in July and August:

> *Bail could often be what we call now "own recognizance." A small community would know who you are and what you were doing with yourself. The practice was "no bail" for murder under any circumstances. Now it is only for "capital murder."*

On the other hand, Restituto (Tuto) Colon Marquez, in the prison for aiding and abetting an assault and robbery at a migrant cabin, could not get bail. He was there for six months or so before Friedman argued successfully for bail. It was questionable whether Tuto should have been in there in the first place but for the machinations of justice in those days. Friedman said:

> *Plea bargains were more informal than now; more of a "gentleman's agreement." In the Jim Haines case, for example, it was argued that any sentence would be a sentence of death because of the man's age.*

Tuto was one of three defendants. There were no public defenders, so the court assigned a lawyer pro bono, much in the manner seen in *To Kill a Mockingbird*. Friedman recalled that well-respected counsel John Conroy III represented the number one suspect. Conroy was upset about losing practice time and fees. He made a bargain with the judge to plead the case and then informed the rest of the team after the fact. There was little to do but agree to the terms. According to Friedman, "At the trial, Conroy pointed to Tuto and I said, 'He did it.' The trials were faster."

At the Burlington County Jail, as with all county jails in New Jersey, no one stayed longer than a year. Most were there for a few days or weeks. If one's sentence ran longer, or the sentence was execution, the courts remanded one to state prison. For the most part, inmates' attorneys routinely appealed crimes

The Burlington County Prison

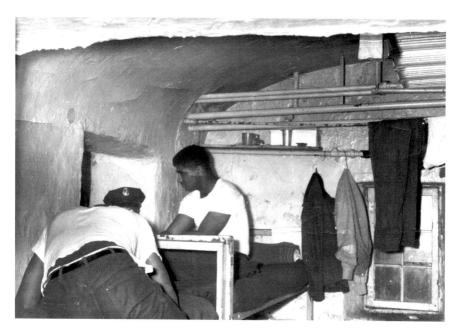

In "the subway." The lower level of the prison, once the workshop, held the road gang and others. The prisoners were crammed together with little or no space, and the odor was impossible to wash off. *Prison Museum Association.*

that called for long sentences to the state courts if the accused had the funds or the case was adopted pro bono by an organization or firm.

The inmates who lived in "the subway" were those who went out to work on outside cleanup jobs or road gang work. They had more privileges than the prisoners upstairs. The ones who went out to work were already sentenced to 364 days or less, whereas the ones upstairs had not gone to trial, were back from state prison for retrial or had not yet been sentenced. Stan Fayer recalled:

> *Many things happened in the short time I was there. On my first day I was being shown through by Officer Leon Walker, and we came to the subway, where the road gang lived. It was winter, and it was the job of the prisoners to keep the coal fire going in the furnace on the South wall of the prison basement. I was a little nervous to be in the room with nothing in between me and about twenty-five prisoners, but as we walked through, Leon spoke to them as we went, and they seemed friendly. Leon explained that they were in for minor crimes and weren't violent, [and] I felt more at ease. When we reached the area where the furnace was, a prisoner by*

the name of Billy Watt was cooking something in the open door of the coal furnace. When I asked him what he was doing, he said, "I'm makin' somethin ta eat." It was a pigeon he had caught in the prison yard. So much for my first day.

As Stan Fayer noted, the guards for the road gang were sophisticated in dealing with the potential for contraband making it back to the jail. Prisoners always found something by the side of the road while gathering trash—money, knives, personal items, etc.—and these could easily find their way inside. The guards made a deal, whereby they would set aside anything a prisoner found to be returned to him when he was released. As Stan recalled, all the prisoners on the crew complied:

> Then there was Ray Watt. Ray was a con man, and a good one. Everyone liked Ray. Ray became the cook, as the prisoners were the cooks. Talk about the county saving money, Ray was able to take eight chickens and make enough chicken salad to make eighty chicken salad sandwiches and a huge pot of chicken noodle soup, with lots of noodles to stretch it, and also feed the guards. On top of that, he always saved a leg for me.
>
> I remember that while Ray was in jail, the singer Jack Jones[88] called and asked for Ray and told us if there was anything he needed to let him know. When Ray got out of jail he told me to go to the Latin Casino any time and ask for his table, so one time I went there and asked for his table and was taken right up front by the stage.
>
> During a performance by Robert Goulet, Ray showed up. The next thing you know, he is up on the stage singing with Gulet.
>
> Ray, although very good at being a con, wasn't mobbed up as much as he most likely would want to be; [he] didn't have much to offer them. One time when the warden sent out word that a reporter was coming through the jail, Ray got word of it and made up a T-shirt that said, "SAVE ME, I'M THE LINDBERGH BABY," and wore it when the reporter showed up.
>
> We had a prisoner by the name of Jimmy Fourver. He was a juvenile that was accused and later convicted of murdering his aunt. He stabbed her seventy-two times. Jimmy was a juvenile, and because of his age, we kept him on the first floor and away from other prisoners.

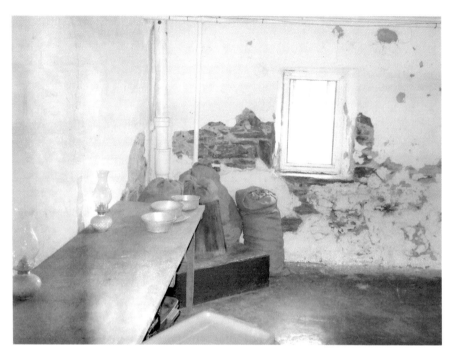

Above: The kitchen area. Cooking for the inmates was done here. *Author photo.*

Left: Perhaps this is one of the religious paintings mentioned by Stan Fayer. Could this be one of Richard Perridan's pieces? *Author photo.*

Stories from the Stones

To help keep him occupied, I would bring him paint-by-number sets, which he would complete. When done with the set he would send the leftover paint upstairs to the prisoners to paint with. Richard Perridan, a prisoner awaiting trial for rape, would paint religious paintings on the wall. I guess the people restoring the jail felt these were some kind of works of art and have gone to some lengths to preserve them.

Cell 5 was the maximum-security cell—what had been termed the "dungeon" in earlier periods. Despite this attempt to keep prisoners in secure lockup, the conditions at the prison were becoming untenable. And not only the inmates were at risk. According to Fayer:

Not all the incidents were funny. I remember a prisoner named Ray Haines, from Browns Mills, who tried to kill his girlfriend's father with a shotgun, and he was going to split the insurance money with the girlfriend's mother. Well he did not kill him but wounded him, and he testified against Ray. I knew Ray before this happened. For some reason Ray ended up in Cell 5 for misbehaving. One night I was making my rounds, a large stone from the window ledge came crashing down behind where I had just walked. Ray must have found it to be loose, pried it free and pushed it down, almost hitting me.

Another time the state police had brought in a prisoner who was very muscular, and he was going nuts (that's the only way I can think of to describe him). We put him in Cell 5, where he broke his handcuffs apart and proceeded to push and bang the inside cell door. The doors are on hinges with a lock on the opposite side. Soon I noticed that where the door was attached to the wall on the hinge and lock sides, every time he slammed the door, powdered cement came out. I was sure that door was coming of the wall.

Luckily, he tired before it did. By morning, he was calm, and when he was out of there, we had to repair the concrete.

Richard Perridan—the painter of the walls—had taken his toothbrush and sharpened the handle to make a knife out of it by rubbing the handle on the concrete and shaping and sharpening it into a blade. He attempted to stab or cut me as I walked by the cell, but I made a point of walking far enough away from the cell doors so they couldn't reach me. I learned that from Fred Schildkamp.

The Burlington County Prison

Of Guards and Crew

Stan offered a good picture of the prison guards and their personalities. In earlier periods, we learned most often about a warden or keeper because something went wrong. The day-to-day effort to keep control and order requires a certain type of person. Failure means embarrassment and possible censure, as in the case of Eddie Adamski's or with Joel Clough's keepers. Images of rough-and-ready prison guards from the movies don't gel with the people Stan talked about. They had tough skin, but a sense of fair play seemed to be the order of the day:

> *Some of the names of the people I worked with were Warden Joe O'Conner, Fred Schildkamp, Kenny Gilbert, Gene Wolf, Charlie Salber. Bill Burgan, Leon Walker, Clyde Cassaboom, Charlie Holman, Miss Minnie, Verna Davis, Ms. Spinner and myself.*
>
> *Fred was the most serious of the people I worked with. I'm not sure if he was the senior guy, but if we had sergeants, Fred would have been it. Fred was about five-foot-seven and slender build. I'm guessing he was in his middle to late forties and prematurely gray. He was very serious about his job and had taken many correspondent courses from the Federal Bureau of Prisons, which he talked me into doing.*
>
> *Fred was there during a time when there were jail escapes and was constantly vigilant of what was going on inside. He was also responsible for almost all the lockdowns and searches. I think he had two children. He was a great guy to work with, and you could learn a lot from him, and he was willing to teach you if you wanted to learn.*
>
> *Bill was a bull of a man, about six feet tall and very broad. I would say he was about sixty years old and had gray hair, and a big round face. I was told he was an ex–pro wrestler and was very rough with the prisoners. He liked to throw them around and show them he was the boss. I suppose this would not be tolerated today.*
>
> *Charlie Salber was also an older man about sixty or more years old. He was about five feet, ten inches tall. Slender with an almost bald head. He was sort of quiet and went about his business. I always got the feeling that Charlie was paranoid in the jail and was always on his guard. I never discovered why; maybe something that happened years past.*

Stories from the Stones

Leon Walker was short—about five feet, five inches tall—about forty-five years old and with a very significant stutter. The more upset he got, the more he stuttered, until you almost could not understand him. I remember him getting mad at a prisoner and shouting, "I'm gonna kkkkkkkkkk kill you." It took him so long to get it out, I think he forgot what he was mad about. He always carried a blackjack and was not afraid to use it. He was from Burlington City, and I don't know anything about his family.

Miss Minne was a short, stocky, dark-skinned black lady that was very nice to everyone, fellow employees and prisoners alike. She spoke in a high-pitched voice and spoke fast. On the twelve-to-eight shift, we had to bring our own meal, either sandwiches or if you wanted a hot meal the men officers had to cook it. Sometimes when Miss Minne and Leon Walker and I worked together, I would get steaks from my father's store and cook them for us. We didn't do it too often, but it was a nice treat. Miss Minne was from Burlington City. I don't know what her last name was or anything about her family.

Verna Davis was a tall, stout woman about fifty years old, and it seemed like she was about six feet tall, sort of soft spoken unless you pissed her off, then you didn't want to get in her way. She lived in Pemberton Township, off of Arnystown Road. I think she was a widow but had a son that lived with her.

Joe O'Conner was the warden. He was a tall, soft-spoken man as I remember him. I was twenty-one, and I'm guessing that he was in his early fifties. He was of average height and thin build. He had brown hair and combed it straight back. He was always neatly dressed with a jacket and tie. He lived in Mount Holly, and one time I had to deliver something to his house and met his wife and daughter, who both had red hair. I didn't have much contact with him, as he worked days and I worked mostly nights, but when I did it was usually pleasant.

Francis "Luke" Brennan was the longtime sheriff who was ultimately in charge of the jail and Joe O'Connor's boss. Luke was a longtime political favorite in the county. He was a stocky-built guy who always seemed happy. (Luke's son, John, is presently an assistant prosecutor in Burlington County.) He had gray hair, a deep cleft in his chin, a strong handshake and usually had a big grin on his face, although son John may have seen different at times. John may be a good person to talk to.

The Burlington County Prison

A native drawn by one of the prisoners, though the intent is not clear. It is possible the inmate was one of the Renape nation (Lenape), which has a reservation in the county. *Author photo.*

Mike Chanti and A. Chester Melecki were undersheriffs that Luke depended on if there was a problem. Both these men were always nice to me—maybe because the pay was so poor that they had a hard time keeping help. I think my pay was $4,700 per year, and that wasn't even good for those times. Burlington County is notoriously bad pay.

The jail was segregated. I think mostly by the choice of the prisoners. The first cells on the second floor were white, and the cells past number five were black. No one seemed to think a whole lot about it, and it seemed to keep racial problems to a minimum. Once in a while, there would be some racial slurs from both sides, but there were no Supreme Court decisions about jails in those days.

Stories from the Stones

In 1965, the freeholders determined that the old prison was derelict. It could no longer hold even the most taciturn inmate securely. Staffing the prison became difficult. As it prepared for the construction of a new courthouse and prison complex, the county used the abandoned National Guard armory next door, along Grant Street, to house prisoners. This building no longer exists. Fayer continued:

> *I worked in the prison until it closed and moved to the old armory. I took the last prisoner out of the jail, cuffed him to myself and walked him around the corner to his new home and can remember thinking how significant it was that he was the last prisoner to leave the place. His name was Estaban "Chico" Availas or Steven Brown (one in the same), and he was back from state prison for a retrial for murder.*

There were talks of the jail closing beginning in the 1920s, when inspectors officially declared the prison to be overcrowded and unsanitary. Obviously, this did not happen. The wheels of government are never fast. The final day that Robert Mills's prison was in use was November 23, 1965.

12

The Prison Museum

In my country we go to prison first and then become president.
—*Nelson Mandela*

Authorities slated the Historic Burlington County Prison for the scrap heap several times during its long and somewhat illustrious history. The final straw came in 1965, with the push for reform throughout the United States and pressure mounting from legal and civil claims against the county for conditions at the site.

In addition, the county population was growing significantly, as people moved out of Philadelphia to the suburbs. This exodus was not new; people from Philadelphia had historically chosen sites along the Delaware River in New Jersey for summer homes, retirement homes or simply a way to get out of the city. It meant, however, that the 1796 courthouse in Mount Holly was no longer able to sustain the flow of cases.

Freeholders decided to do a complete reconstruction of the various county justice buildings. In keeping with reform and security issues, they opted for a unified building, designed for the purpose (sound familiar?). They slated the old prison, with peeling plaster, antique plumbing and crumbling stones, for demolition. Efforts to keep the prison as a monument and historical property began almost immediately.

Stories from the Stones

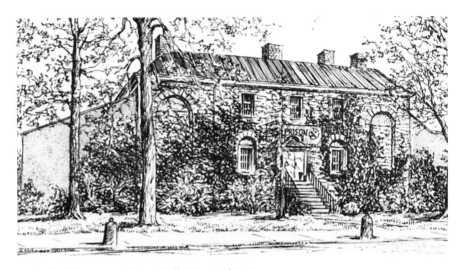

A sketch of the prison. *Mount Holly Historical Society.*

THE JAIL BECOMES A MUSEUM

On February 24, 1954— some hundred years after the jail's obsolescence was generally recognized—Burlington County announced plans to demolish the building and build an office building on the site. While a dozen or so citizens spoke against the plan, the freeholders expected no real opposition. The plan would rid the county of a lowering gray building, a jail in which mere incarceration was probably going to be held as "cruel and unusual punishment" and therefore unconstitutional and a building whose seven-by eight-foot rooms and general atmosphere precluded any other use. They would gain much-needed office space and a new jail for only a million and a half dollars. Who could object?

County residents, in unprecedented numbers, objected.

The unprepossessing old building seems to have earned the subconscious but very real affection of a lot of county residents, and these people reacted swiftly. Led by Jay Tomlinson, a leading attorney and preservationist, the suddenly and unexpectedly aroused citizens, within four days of the announcement, formed an Association for Preserving Historic Burlington County. Tomlinson and other key leaders of the preservation movement were taxpayers and part of the county establishment, not win-at-all-costs radicals.

By March 15, five thousand residents had signed petitions opposing demolition. On April 1, the weekly *Mount Holly Herald* ran on its front

page a fake photo showing demolition in progress, adding fuel to an already raging fire. By April 15, the freeholders had received 245 petitions with 7,426 signatures, or 5 percent of the county's total population, and announced a public hearing on the matter. On May 27, three months after their vote to tear down the old jail, the freeholders voted to preserve it.

An aroused public had raised its voice and been heard. However, the county still needed a new jail, and the Robert Mills jail really had no other use but that of becoming a museum.

When in November 1965 the prisoners were moved around the corner to a new, temporary jail in a converted armory, Tomlinson, Delia Biddle Pugh and other preservationists formed the Citizens Committee for the Historic Burlington County Jail. Delia Biddle Pugh was an outstanding member and benefactor of both the Burlington County Historical Society and the Friendly Institution and an important figure in popularizing the historical significance of Burlington County. With the backing of influential residents and the general citizenry of the county, the prison took on its new role.

The committee worked with county officials on such issues as the legality of a county owned and operated museum, how other county-owned properties functioned and so forth. The resulting Historic Burlington County Prison Museum opened on April 14, 1966, with a county-employed curator and visiting hours every Tuesday through Saturday. To ensure continued public participation in and support for the museum, Tomlinson, Mrs. Biddle-Pugh and seven others incorporated the Historic Burlington County Prison Museum Association (PMA) on July 15, 1966.

In its first month of operation, the new museum had fifteen hundred visitors. Initially, the novelty of the old building—with its dark, dank cells; small barred windows; and abundant prisoner-drawn graffiti augmented by special exhibits (military equipment loaned by Fort Dix; Argentine art and engravings; Anthony Gonsalves's pottery, sculpture and paintings; Boehm birds)—kept the PMA and public interest up.

However, visitors eventually declined in number, PMA leadership died or lost enthusiasm and the PMA membership declined in numbers, participation and commitment. When the county-employed curator retired in 1981, the county transferred management responsibility to the Cultural and Heritage Affairs Office, and volunteer docents greeted visitors.

Opening hours declined to the two days of the weekend, and only between April and November. While a one-day-a-year "haunted prison" event manned (or "ghosted") by volunteer aficionados of horror supplied

the PMA with money, membership and interest declined to the point that not even all board members appeared at meetings. The lack of public interest was paralleled by a lack of anything more than the most routine maintenance of the facility.

NATIONAL REGISTER AND REBUILDING

Reading, hopefully the Scriptures—a figure sitting on a bed in one of the recreated cells. In keeping with the original concept of the prison, he is reading and, perhaps, contemplating his crime. *Author photo.*

By 1987, the jail roof was failing, its cornice was rotting, its interior paint was flaking off in one-eighth-inch-thick pieces and the one restroom was fairly worn out. Interestingly, that year the building received its designation as a Registered National Historic Landmark. The October 21 ceremony at which the National Landmark received its plaque focused public attention on the building's condition. Increased awareness of the presence of a National Register building in the county gave the preservation effort political impetus.

Money for a new roof was approved in 1990, and the contract for the work was signed three years later. Since the hammering and banging major repairs would entail would stress the already failing paint, the some ten years' worth of prisoner art, calendars, game scores and autographs covering the walls of the second floor were photographed by a professional preservation firm, at the PMA's expense, and all artifacts and records were removed by PMA volunteers to a rental storage unit.

The new roof and cornice were completed in 1995, but by that time the interior paint, hazardous because of its lead content and peeling off in sheets, had to be removed and properly disposed of—a time-consuming and expensive proposition. New, badly needed restrooms were included in the project.

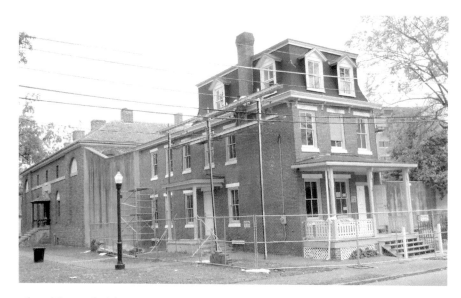

Above: The warden's house, constructed in 1887 as an office for the warden and residence for his family and deputy. *Author photo.*

Below: The warden's house. The refurbishing that took place in 2010 was intended to make the building available for tours, as well as provide a home to archives and materials for the historical society. *Author photo.*

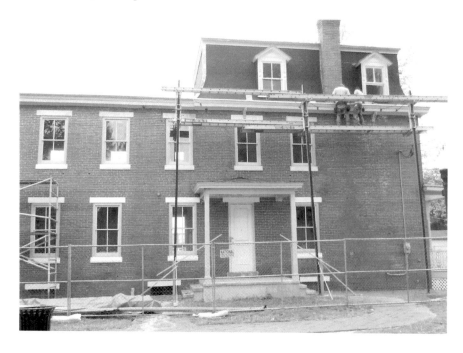

Stories from the Stones

By this time, only a few active PMA members remained. These few held a "resuscitation luncheon" in March 1998, choosing new and energetic leadership, and in essence started anew. When a Certificate of Occupancy was finally issued, a partially resuscitated PMA celebrated with an April Fools' Night Haunt at the old jail, put on by the drama club of the local high school and attended by over six hundred people—a source of both needed money and public interest.

The county set up a Department of County Parks and gave it responsibility for the prison museum. A curator was hired, regular visiting hours were set and expanded and new exhibits were professionally installed. Renovation of the warden's house, started in 2010, allows its use as a repository for PMA archival materials and those of other groups in the county.

At the same time, PMA membership increased in both numbers and willingness to participate in getting the prison the attention and visitation it deserves. The prison serves as the venue for several fundraising and civic events in town, including the Gala at the Gallows and the Crown Forces Camp for the Annual Battle of Mount Holly Commemoration. A new, exceptionally talented and hardworking group of horror genre devotees launched an annual "Haunted Prison" event, which provides the money for publications and allows the PMA to host other events.

The prison lives on, into its third century.

Tours like this bring the prison to life for visitors and schoolchildren through the year. Grants and donations from visitors make the museum possible. *Prison Museum Association.*

Postscript

The original idea of having individual cells where prisoners lived, ate, worked and slept in isolation was abandoned for a number of practical reasons. Among these was the cost. The system was replaced by that seen in the Auburn, New York prison, which housed inmates in individual cells but had congregate eating, recreation and work facilities. However, the innovation continued the "silent system," whereby prisoners were forbidden to communicate with one another at any time under threat of solitary confinement and severe punishment.[89] The Philadelphia System retained the individual disposition of prisoners well into the nineteenth century, and the Burlington County Prison was of this model.

Reform in the 1970s included permitting an inmate greater choice and expressions of individuality. As can be seen in Liston's review, the "new" efforts were not much different from the original purpose of the reformers of the system in 1811:

> *Better classification of inmates is a major goal. If the inmates can be separated by the nature of their offenses, background and chances for rehabilitation, it is believed this will make prison management easier and increase the chances for reform. The experienced criminal, the aberrated will have less chance to contaminate the person who sincerely wants to reform.*[90]

Without delving too deeply into penal reform in the twenty-first century, it is easy to see that the intentions of the designers of the Burlington County Prison were far ahead of their time. Putting the theories into practice fell victim to the exigencies of the American justice system. Without alternatives to long-term incarceration (death and dismemberment were no longer fashionable), the facilities quickly filled and became untenable.

The short terms of most prisoners in the county jail meant that the theories of rehabilitation never had time to be tested. The revolving door applied to many vagrants, drunks and "loose" women meant that none were in place long enough to learn a trade or gain self-awareness.

In addition, there is the sense that every effort at reforming a degrading penal system has led, inevitably, to failure and to the institutionalization of a new set of aberrations. This seems apparent in any congregate setting attempting to provide rehabilitation or care with limited resources and untested strategies.[91] Society competes with the high principles of the reformer for assurance

Stories from the Stones

Left: A cell door reconstructed according to what the prison had from the start. It's formidable but apparently not impenetrable. *Author photo*.

Below: Rear view, 1937. The WPA's Historic Building Survey provides significant information on what the prison was like at the time. It served as part of the rationale for placing the building on the National Register of Historic Places. *Prison Museum Association*.

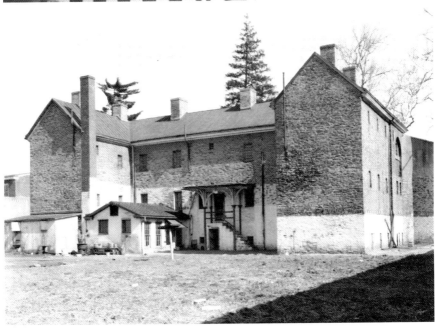

The Burlington County Prison

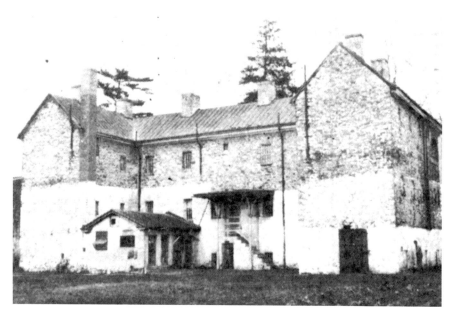

Prison view, post 1927. A familiar pose for the old place, showing the variation in whitewashing. Apparently no one would go above the first floor at that time. *Prison Museum Association.*

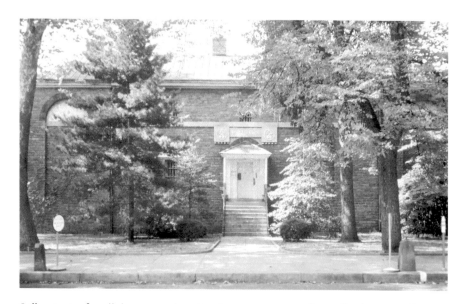

Still majestic after all these years, the prison hosts many events, from a fundraising at the gallows, to the 1776 occupation of the town by Hessians, to the haunting that arrives each October. Unlike its former guests, today no one *has* to stay if they don't want to. *Prison Museum Association.*

that the prison is performing the primary role of separating criminal and noncriminal. As Allen notes, and others confirm:

> *For an instant in the 1830s the mixed motive of inmate reform, the preservation of established values, the discouragement of crime and the incapacitation of criminals, the maintenance of prison discipline, and the avoidance of burdensome taxation may have seemed capable of harmonious reconciliation. If so, the optimistic expectations did not last long.*[92]

For the most part, the reforms died along with the initial proponents and were followed by another cycle of decay and reform. This cycle has continued to the present day. The Historic Burlington County Prison remains a monument to the continuing effort of society to become ever more progressive and a testament to our need to constantly reinvent what it means to be civilized.

Notes

Chapter 1

1. Newman, *Embodied History*.
2. Ibid.
3. McKelvey, *American Prisons*.
4. Gottlieb, "Theater of Death."
5. Ibid.
6. Wikipedia, "Assizes: England and Wales," http://en.wikipedia.org/wiki/Assizes_(England_and_Wales).
7. Newman, *Embodied History*.
8. Caesar Beccaria, "An Essay on Crimes and Punishments," http://www.constitution.org/cb/crim_pun.htm.
9. Newman, *Embodied History*.
10. Beccaria, "Crimes and Punishments."

Chapter 2

11. Burlington County Freeholder Records, 1798.
12. L.H. Officer and S. Williamson, "Measuring Worth," http://www.measuringworth.com.

13. Burlington County Freeholder Records, pp. 318–19.
14. Ibid., May 11, 1808.
15. Ibid., February 1809.
16. Janet Sozio, "Burlington County Prison Museum," Speech, 2004.
17. Bryan, *Robert Mills*.
18. Robert Mills, "Design for a Prison for Burlington County New Jersey: Comprising a Debtors Gaol and Workhouse," Manuscript in the possession of the Mount Holly Lyceum and Library and on permanent loan to the New York Public Library.
19. Ibid.
20. Ibid.
21. Burlington County Freeholder Records, May 10, 1809.
22. Ibid., February 11, 1811.

Chapter 3

23. Mann, *Republic of Debtors*.
24. Newman, *Embodied History*.
25. Hansen, "Bankruptcy Law."
26. Newman, *Embodied History*.
27. Ibid.
28. "Jerseyman," http://forums.njpinebarrens.com/ghost-towns-forgotten-places.
29. Newman, *Embodied History*.
30. Burlington County Freeholder Minutes, May 1819.
31. Rizzo, *Mount Holly*.

Chapter 4

32. Lunde, *Organized Crime*.
33. Newman, *Embodied History*.
34. *New Jersey Mirror*, Microfilm.
35. Rizzo, *Parallel Communities*.
36. Finkelman, "State Constitutional Protections."
37. *New Jersey Mirror*, August 18, 1836.
38. Rizzo, *Parallel Communities*.
39. McKelvey, *American Prisons*.

40. "Rob Scott," http://www.24hourtrading.co.uk/blog/top-5-most-gruesome-forms-of-capital-punishment-585.
41. Death Penalty Information Center, http://www.deathpenaltyinfo.org/part-i-history-death-penalty#19.
42. New Jersey Archives, Burlington County Indictments, 1832.
43. Burlington County Freeholder Minutes, Archives, 2010.
44. Burlington County Prison Museum Association, *Authentic Confession*.
45. Ibid.

Chapter 5

46. *Mount Holly Mirror*, 1859.
47. Joseph Bonaparte, brother of Napoleon and deposed ruler of Spain, moved to Bordentown in the 1820s and established a well-known and well-visited estate along the Delaware River at Crosswicks Creek.
48. Prince Murat, cavalry leader under Napoleon, accompanied Joseph Bonaparte to America and built a handsome house and some row homes for tenants along the road into town from the estate. These remain in use today. Coulter would have had to walk past these homes to and from town.
49. *Mount Holly Mirror*, 1859. Statements by James Coulter at the trial name the location of the store.
50. *Mount Holly Mirror*, December 1863.

Chapter 6

51. *Mount Holly Herald*, December 1857.
52. Allsopp, "Minister Led Push."
53. *New Jersey Churchscape* 22 (February 2003), http://www.njchurchscape.com/index-Feb-03.html.
54. Scrofula (scrophula or struma) is any of a variety of skin diseases; in particular, a form of tuberculosis, affecting the lymph nodes of the neck.
55. Historic Burlington County Prison Archives.
56. "McAdam," http://en.wikipedia.org/wiki/Macadam.
57. Historic Burlington County Prison Archives.
58. Hansen, "Bankruptcy Law."
59. Ibid.
60. Botkin, *American Folklore*.

61. *Mount Holly Herald*, November 8, 1873.
62. Kirchwey, "New Jersey Prison Inquiry."
63. Historic Burlington County Prison Archives.

Chapter 7

64. Burlington County Prison Museum Association, *Wesley Warner's Crime.*
65. Smithville Conservancy, "Murder of Lizzie Peak."

Chapter 8

66. Secret Service, http://www.secretservice.gov/history.html.
67. "Fingerprints," http://en.wikipedia.org/wiki/Fingerprint#Europe_in_the_17th_and_18th_centuries.
68. Ibid.
69. Reisinger, *Master Detective.*
70. Pratt, *Cunning Mulatto.*
71. Ibid.
72. Historic Burlington County Prison Archives, Jail Registers.
73. Pratt, *Cunning Mulatto.*
74. Ibid. Much of this story comes directly from Pratt's interviews.
75. Ibid.
76. *Times of Trenton*, http://trentonhistory.org/Index/Index1906.html.
77. Pratt, *Cunning Mulatto.*
78. Ibid.
79. Ibid.

Chapter 9

80. Machi, "AmericanMafia.com."
81. The Delaware Valley Rhythm and Blues Society.
82. Pratt, *Cunning Mulatto.*
83. Interview with Stan Fayer, 2010.
84. Interview with Charles Farner, October 2000.
85. Ibid.

Chapter 10

86. Bardsley, "Boston Strangler."
87. Ibid.; see also, Kelly, *Boston Stranglers*.

Chapter 11

88. Jack has had lots of hits—"Lollipops and Roses," "Call Me Irresponsible," "Love with the Proper Stranger," "The Impossible Dream" and others. But he is best remembered by many for singing the theme song for the very popular TV series *Love Boat*.

Chapter 12

89. Liston, *Edge of Madness*, 41; Allen, *Decline of Rehabilitative Ideal*, 13.
90. Liston, *Edge of Madness*, 124.
91. Allen, *Decline of Rehabilitative Ideal*, 32.
92. Ibid., 53.

Bibliography

Allen, Francis. *The Decline of the Rehabilitative Ideal*. New Haven, CT: Yale University Press, 1981.
Allsopp, Mary. "Minister Led Push to Create Ocean County." http://www.oceancountygov.com/history/haywood.htm.
Bardsley, Marilyn. "The Boston Strangler." http://www.trutv.com/library/crime/serial_killers/notorious/boston/index_1.html.
Botkin, B.A. *American Folklore: Stories, Ballads and Traditions of the People*. New York: Crown Publishers, 1944.
Bryan, John. *Robert Mills: America's First Architect*. New York: Princeton Architectural Press, 2001.
Burlington County Prison Museum Association. *A History of Wesley Warner's Crime*. Mount Holly, N.J.: 1894. Reprint, 2003.
———. *The Authentic Confession of Joel Clough*. Philadelphia: R. DeSilver, 1833. Reprint, 2005.
Chadwick, Bruce. *I Am Murdered: George Wyth, Thomas Jefferson, and the Killing that Shocked a Nation*. Hoboken, NJ: John Wiley & Sons, 2009.
Finkelman, Paul. "State Constitutional Protections of Liberty and the Antebellum New Jersey Supreme Court: Chief Justice Hornblower and the Fugitive Slave Law." *Rutgers Law Journal* 23, no. 753 (1992): 768–74.
Gottlieb, Gabriele. "Theater of Death: Capital Punishment in Early America, 1750–1800." PhD diss., University of Pittsburgh, 2005.
Hansen, Bradley. "Bankruptcy Law in the United States." EH.Net Encyclopedia. http://eh.net/encyclopedia/article/hansen.bankruptcy.law.us.

Bibliography

Kirchwey, George W. "Report of the New Jersey Prison Inquiry." *Journal of the American Institute of Criminal Law and Criminology* 9, no. 2 (August 1918): 207–39.

Liston, Robert A. *The Edge of Madness: Prisons and Prison Reform in America.* New York: Franklin Watts, Inc., 1972.

Lunde, Paul. *Organized Crime.* London: The Brown Reference Group, 2004.

Mann, Bruce. *Republic of Debtors: Bankruptcy in the Age of American Independence.* Cambridge, MA: Harvard University Press, 2002.

McKelvey, Blake. *American Prisons: A Study in American Social History Prior to 1915.* Montclair, NJ: Patterson-Smith Publishers, 1936.

Newman, S.P. *Embodied History: The Lives of the Poor in Early Philadelphia.* Philadelphia: University of Pennsylvania Press, 2003.

Nickell, Joe, and John F. Fischer. *Crime Science: Methods of Forensic Detection.* Louisville: University Press of Kentucky, 1999.

Pratt, Fletcher. *The Cunning Mulatto and Other Cases of Ellis Parker, American Detective.* New York: Smith and Haas, Inc., 1935.

Rizzo, Dennis C. *Mount Holly: A Hometown Reinvented.* Charleston, SC: The History Press, 2006.

———. *Parallel Communities: The Underground Railroad in South Jersey.* Charleston, SC: The History Press, 2008.

Solomon, Hassim M. *Community Corrections.* Boston: Holbrook Press, 1976.

Stellhorn, Paul, ed. *Jacksonian New Jersey.* Trenton: New Jersey Historical Commission, 1977.

Takagi, Paul. "The Walnut Street Jail: A Penal Reform to Centralize the Powers of the State." *Punishment and Penal Discipline* (1980): 48–56.

Collections and Microfilm

Historic Burlington County Prison Museum Association Collection
Mount Holly Herald, Microfilm, Burlington County Library
Mount Holly Historical Society Collections
Mount Holly Library Collections
New Jersey Mirror, Microfilm, Burlington County Library

Bibliography

Interviews

Farner, Charles (by Janet Sozio)
Fayer, Stan (by Dennis Rizzo)
Friedman, Judge Victor (by David Kimball)

Internet Sources

Constitution Society, http://www.constitution.org/cb/crim_pun.htm.
County Insane Asylum, http://forums.njpinebarrens.com/ghost-towns-forgotten-places.
Death Penalty Information Center, http://www.deathpenaltyinfo.org/part-i-history-death-penalty#19.
Delaware Valley Rhythm and Blues Society, http://www.dvrbs.com/camden-stories/CamdenHeadline-061933.htm.
Fingerprints, http://en.wikipedia.org/wiki/Fingerprint#Europe_in_the_17th_and_18th_centuries.
Machi, Mario. "AmericanMafia.com." PLR International. http://americanmafia.com/Cities/Philadelphia.html.
McAdam, http://en.wikipedia.org/wiki/Macadam.
New Jersey Churchscape, http://www.njchurchscape.com/index-Feb-03.html.
New York Times. "Chloroform a Clue in Giberson Killing." August 22, 1922. Available at http://query.nytimes.com/gst/abstract.html.
"The Poor," http://www.flickr.com/photos/brizzlebornandbred.
"Robert Scott," http://www.24hourtrading.co.uk/blog/top-5-most-gruesome-forms-of-capital-punishment-585.
Secret Service, http://www.secretservice.gov/history.html.
Smithville Conservancy. "The Murder of Lizzie Peak and the Smithville–Mt. Holly Bicycle Railroad, Burlington County, New Jersey." http://www.smithvilleconservancy.com/Herald_Peak_BikeRR.php.

About the Authors

Dennis C. Rizzo believes history should be accessible to the average person, not kept in locked cabinets or archives and available only to those with credentials. With this in mind, he has written two books for The History Press on local history in southern New Jersey; this is his third. In each case, he has felt that presenting a good story for the reader trumps provision of a litany of details, genealogy and enumeration. Interested readers can look up the sources and satisfy any need for details. Genealogists are far better than he at discerning the legacy of families and persons.

A career in the field of developmental disabilities, where he was involved in several major systemic and policy innovations, left little time to pursue historical endeavors. Dennis is preparing a manuscript for a new book and has a fictional novel based on local Mount Holly history in press. He continues to prepare journal articles and materials for training and presentations in the field of developmental disabilities and to participate in historical reenactments with his son.

Dennis now lives in Orillia, Ontario (Canada), with his wife and twin daughters, having retired from New Jersey State government in the nick of time. He continues to be involved in local history and civic matters—between writing, fishing and travel. His favorite pastime, however, is being a stay-at-home dad.

About the Authors

Dave Kimball, a widower with four children and three grandchildren, grew up in rural Vermont and attended high school in Stratford, Connecticut. He received a BA, major in history, minor in government, from the University of Maryland. In 1953, his National Park Service career began as an entry-level historian at Fort McHenry National Monument. In 1962, he transferred to the Northeast Region of the Park Service, located in Philadelphia, to work as a historian on a team preparing development and management plans for the Park System Units in the region.

As the years passed, the Park Service changed as historical work lessened and planning and environmental compliance needs increased. Mr. Kimball prepared general management plans for areas as diverse as Ellis Island and Cape Cod National Seashore, and he eventually became regional chief of planning and environmental compliance. In 1983, he returned to being a historian and to Independence National Park to lead Park Service research efforts in preparation for the bicentennial of the United States Constitution.

A year or so after retiring in 1987, the Burlington County office in charge of the old jail called to see if Mr. Kimball would volunteer as a docent one or two days a week. Unfortunately, his wife answered the call, saw an opportunity to get him out of her hair two days a week and volunteered him. Thus, his participation in this book.